NIGHT AND LOW-LIGHT

TECHNIQUES FOR DIGITAL PHOTOGRAPHY

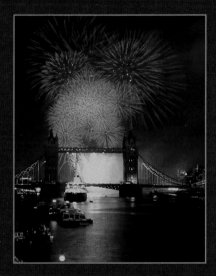
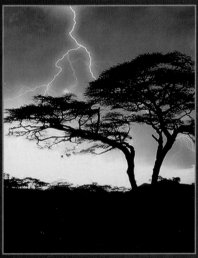
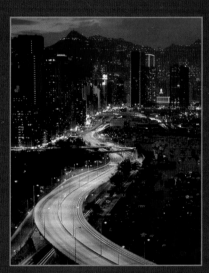

PETER COPE

Amherst Media, Inc. ■ Buffalo, NY

Copyright © 2006 by Peter Cope.
All photographs by the author unless otherwise noted.
All rights reserved.

Published by:
Amherst Media, Inc.
P.O. Box 586
Buffalo, N.Y. 14226
Fax: 716-874-4508
www.AmherstMedia.com

Publisher: Craig Alesse
Senior Editor/Production Manager: Michelle Perkins
Assistant Editor: Barbara A. Lynch-Johnt
Editorial Assistance: Carey Ann Maines

ISBN: 1-58428-174-X
Library of Congress Card Catalog Number: 2005926588

Printed in Korea.
10 9 8 7 6 5 4 3 2 1

Table of Contents

Preface: Inside the Black Box

*I*t was George Eastman who, many decades ago, coined the phrase "You press the button, we do the rest . . ." to emphasize how simple Box Brownie photography had become. It was a medium for the masses that required no effort or interest on the part of the user in the mechanics of photography.

The advent of digital photography almost turned this cozy world on its head. The new photographic technology was borne out of the computer world, a world complete with its own language and technologies that were far from the experience of many—even those who actually use computers. Early evangelists of digital photography would talk long and hard in "computer speak" with the rather obvious result that the technology made only minor excursions outside of the information-technology world.

But that would—and did—change. Today we can, if we choose, adopt the digital spiritual equivalent of George's famous quote. With greater automation and more control, digital cameras today offer flexi-

bility and performance that even George could only dream of. We don't need to know what goes on inside that black—or more likely, silver—box that is the digital camera.

We don't *need* to, but it *helps* if we do. But before you quickly turn the page, fearing what's in the next few paragraphs, don't worry! We're not going to delve deep into the quantum-physics origins of digital imaging. We'll just get to know the key processes and how these can impinge on our ability to get great shots—especially when the conditions are less than favorable. This will help us, too, to understand the limitations of digital cameras and how we can overcome or circumvent them.

It was said by another photographer that the best photographs are not taken in bright sunlight (when, ironically, films give their best rendition) but under more problematic lighting. That's what we explore in this book. And we shall learn that when the sun disappears, our most exciting photographic ventures begin!

INTRODUCTION

Photography, at least for most of us, is perceived as a daylight activity. Except for those special occasions (generally social events) when we use flash, we tend to reserve photography for the sunniest of days. Of course, this is when the world often looks its best. There is something deeply psychological that lifts our mood when the sun comes out—and that works for our photos, too.

This is also something that camera designers, and those that produce film, have taken on board. Most of the film we use is balanced, in terms of its color fidelity and contrast, for sunny days. Just think of those punchy colors on the vacation shots.

Digital photography, and in particular digital cameras, have put a slightly different slant on matters. The electronic sensor that records images in a digital camera is less emotive and more matter-of-fact in its rendition of the world. Digital cameras also allow us to explore new avenues, such as night and low-light photography, without some of the drawbacks imposed by conventional photography. We can, for example, preview our results immediately and make corrections where required. We also have, thanks to the digital darkroom that is our computer, the ability to further enhance and manipulate or work in a way that would be difficult, time-consuming, or downright impossible in the conventional darkroom.

Through this book, we aim to look at the creative opportunities offered in situations where we might ordinarily put the camera away. We'll discover that night and low-light photography, far from being a limited and specialized activity can be the springboard to creating some of the most powerful and evocative imagery.

We begin by asking a simple question, but one that has a more complex answer: What is color? We'll look at color and tone in the context of low-light situations and how the changes that occur impinge upon exposure and camera use.

We'll investigate several diverse options for recording images under the most adverse of conditions.

With our perception and skill improved, we'll investigate several diverse options for recording images under the most adverse of conditions. We will explore worlds as diverse as floodlit cityscapes through lightning and atmospheric phenomena, stage shows, and Christmastime.

The book concludes by looking more at the tools we use. Both cameras and software are discussed as

FACING PAGE (TOP)—As the sun gets low, new opportunities begin. FACING PAGE (BOTTOM)—Sunsets are almost a cliché when discussing low-light photography—but that's with good cause. For color and form ,they are almost unrivaled.

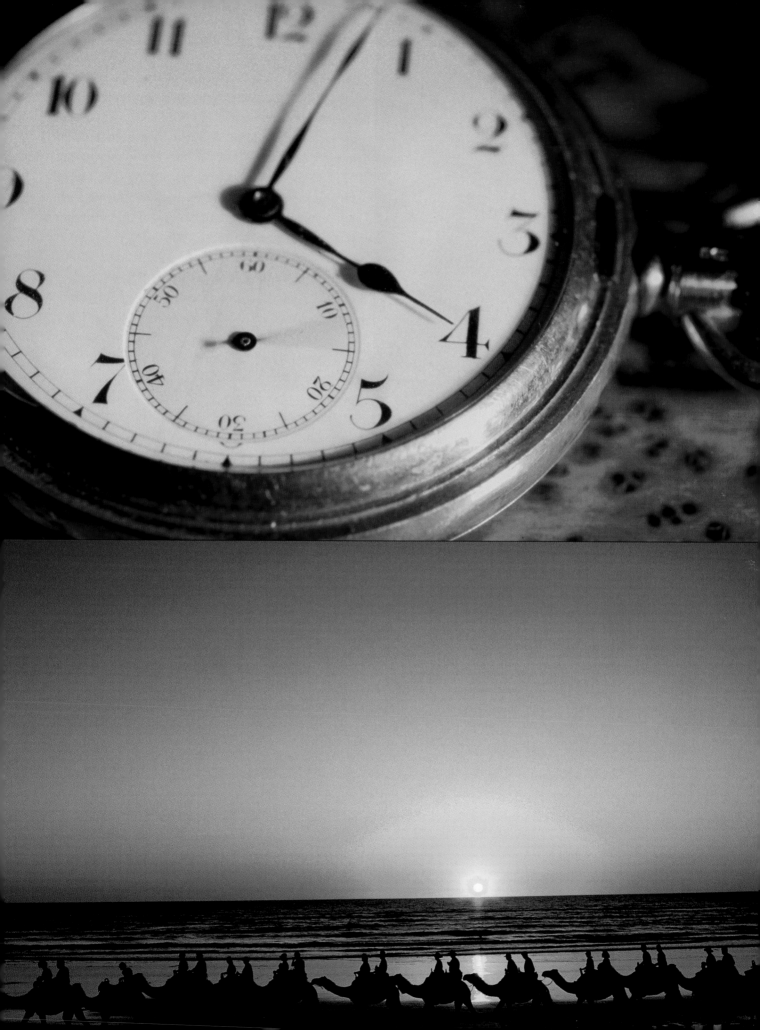

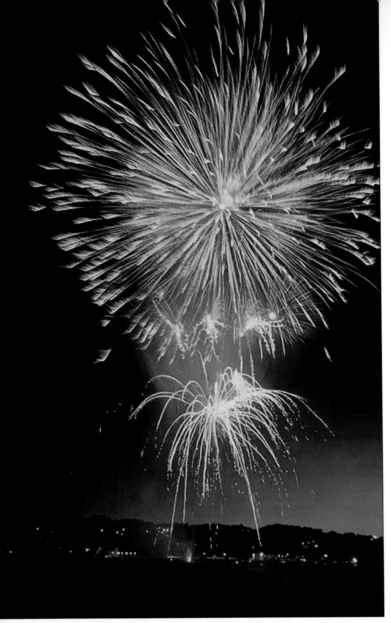

ABOVE—Fireworks and other transient phenomena can be captured forever with a little low-light photo skill. FACING PAGE—Nights in the city can often be more photogenic than the days—the skill comes in knowing how best to capture them.

stant flux and improvement and that not everyone can afford the latest range-topping model, I've included work here that has been taken with a variety of cameras. Most of these have been Fujifilm models (and for those in the know they're the MX2900, MX6900, F401 and S2Pro). The use of Fujifilm cameras is no endorsement and I (sadly) get no remuneration from the company for featuring them.

Why this range of cameras? Well, the MX2900 is a turn-of-the-century 2-megapixel model with limited manual control. It proves that you certainly don't need to have the latest in hardware. The F401 is a truly pocketable device that's small enough to slip in a purse or even shirt pocket. If you don't want to betray your photography, this little camera is perfect—and it delivers 4-megapixel images

Though superceded by current models, both the MX6900 and S2Pro offer lots of creative control. The key difference is that the S2Pro is a full-blown SLR that uses Nikon lenses (ideal if you've a collection of such lenses from your conventional SLR) and most Nikon flash accessories.

But just to prove I'm a little even handed, I've some shots taken with a Nikon Coolpix 5700 (5 megapixels) and an F90 from the same stable. F90? A film camera? Yes, even these have their place in the digital world, as we'll discover!

both are equally important to getting great images. The illustrations, many of which have been taken especially for this book, are designed to show you the capabilities of digital cameras.

■ A WORD ABOUT HARDWARE

We've avoided being parochial about digital cameras. Mindful that digital technology is in a state of con-

■ . . . AND SOFTWARE

Image-editing software today is prolific, with applications to suit all needs, abilities, and price points. The default application here is Adobe Photoshop. Yes, it is the most *expensive*, but it's also the most *extensive* and *powerful*. If you can't do it with Photoshop, it's probably not worth doing. Still, I've kept the use of software to a minimum; we will use it only to improve on already-good images or to achieve a particular effect. Don't feel disadvantaged in any way if you don't own a copy. This book is about how to take great images at night and in low light. It's about inspiration!

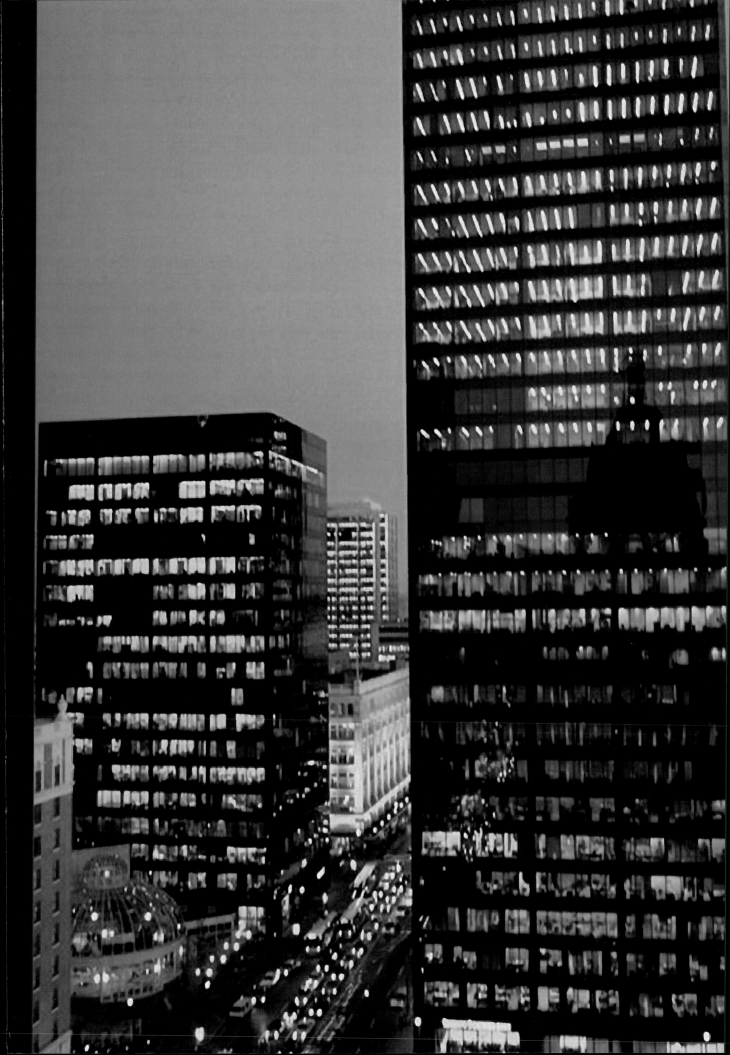

THE LONG DAY'S JOURNEY INTO NIGHT

Be honest. When the light starts to fail, how many of us put away our cameras? Quite a significant number. And that's something of a shame, because the opportunities for great photographs in fading light, or even nighttime, are often more diverse and more compelling than those of daytime.

Perhaps a significant factor in why we put away our cameras is a belief that it's hard to photograph objects at low light levels. There is no doubting that getting good images, and meaningful ones, can be difficult—but there's no reason for them to be that much more difficult than those taken when the sun is high. We may just need to think a little more.

But what, exactly, do we mean by "low-light" photography. When does the light level take on this somewhat vague attribute? In truth, there is no precise point where a light level can be ascribed as becoming "low." For our purposes here (and at the risk of still sounding rather vague) we'll determine it as the point where a camera support is needed to ensure a good exposure. We emphasize "needed" because, of course, many people will say that a support—a tripod or whatever—is desirable at all times. Equally, we won't let any formal definition preclude us from getting great low-light photos even when we can handhold!

There is another question that we need to ask when taking photographs at low light levels, and that is: "Why?" Why do we want to suffer reasonable discomfort, perhaps a little indignity, and a measure of difficulty? It's a question that the enthusiast photographer would eschew as irrelevant. They will argue that where—and when—ever there is light, there is a photo opportunity. That will be our rationale, too. Some low-light subjects, sunsets for example, are

Turn your back on the setting sun to record surreal shapes. These ripples in the sand take on a new life as the sunlight fades away.

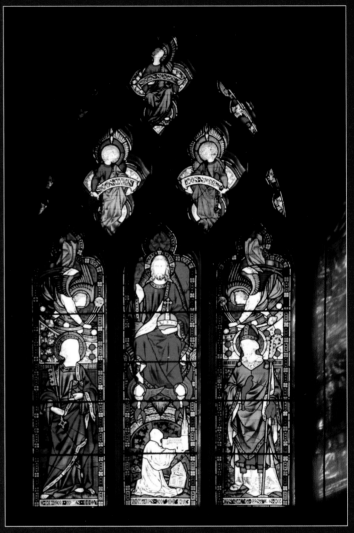

Even in the midday sun, there are great low-light shots to capture. Stained glass is a subject that demands strong daylight.

obvious but even more mundane sights—traffic on a highway, say—can become the basis of powerful imagery. Personal discomfort is no obstacle to great photography!

So how will we set about our voyage of discovery? We'll begin by taking a look at the techniques involved in low-light and night photography. We'll find that, essentially, they are the same as those we'd use in any other form of photography: it is only in the detail that we need be mindful of our particular circumstances. We'll take a look at how we can modify and augment lighting conditions by using flash lighting and other available, artificial means, but doing so without affecting a key component of low-light photos: mood.

Armed with the right tools and knowledge, we'll start exploring low-light photo opportunities. When we start putting our mind to it, we'll soon realize that far from being a photographic niche, low-light imaging actually encompasses a vast array of subjects. We

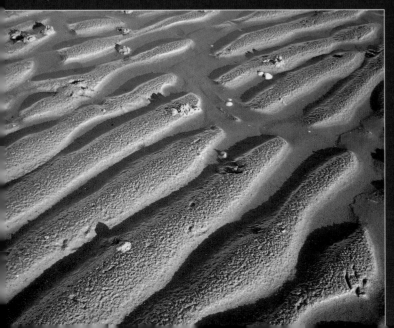

mentioned just a few in the introduction, but think about it again. Sunsets and cityscapes—obvious perhaps. But then we have other weather phenomena—lightning, evening clouds, and even noctilucent clouds. The city at night can be recorded as broad, sweeping panoramas, but is equally represented by details of floodlit buildings, shop windows, or even as a foil to the actions of passing strangers or street performers, Move inside (so weather need be no obstacle either!) and we've more opportunities from the still life of building interiors through the unusual and sometimes surreal cameos offered by stage theatrical performances or shows. All this and we haven't even touched on special events—Christmas and holidays, for example—that give even greater prospects. Conquer the fear and those photographic night terrors, and you'll become a photographer 24/7!

To become competent we need just a little theory and understanding of the way light works. And how it, along with color and tone, changes. These are the armchair topics for this section.

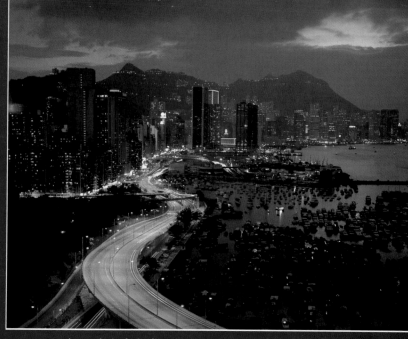

ABOVE—As the sunlight fails, floodlighting takes over. Balance the two for some impressive shots. BELOW—Cityscapes make great subjects at all times of day, but in the evening twilight they become even more expressive, lit only by artificial tracery.

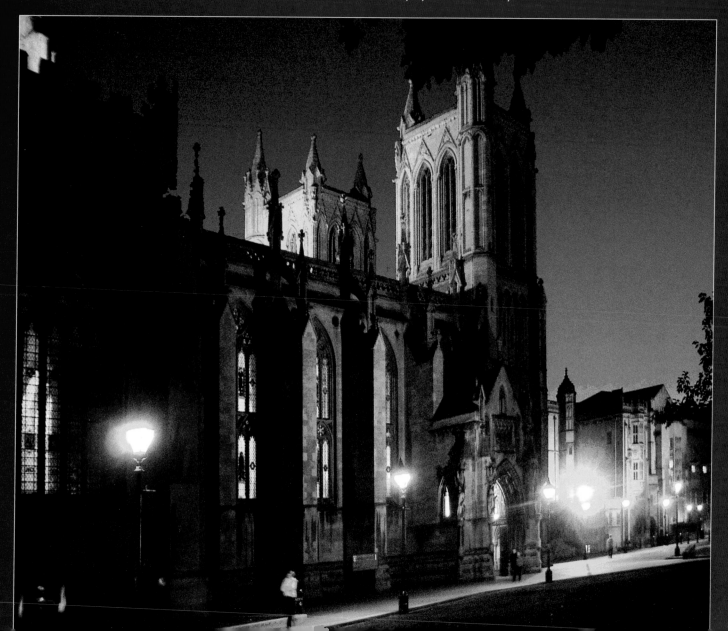

1. Light and Color

The ethos of the creators of digital cameras is to produce a tool that records the color and light in a scene as faithfully as possible. Of course, we would all like our images to be exact copies, but the vagaries of sensor construction and the ensuing electronic and digital processing mean that we ultimately get a close approximation.

We are, though, in a better position with regard to color fidelity than we were in the days when we had to consider our choice of film stock. The degree of variation in color rendering, contrast, detail, and speed were (and, indeed, still are) immense. It often took a photographer some time to audition a range of film types before finally settling on the one that most closely matched his or her style.

We are in a better position with regard to color fidelity than when we had to consider film stock.

The neutrality of a digital camera sensor has been seized on by many to decry the medium. They argue that film type and performance contribute actively to the final photograph. Think of the fine detail of a Kodachrome or the vibrant colors of Fuji's Velvia. This variation is swept aside by digital technology. It's a fallacious argument. We can endow our images with the characteristics of any film stock when we manipulate our image—and more besides.

However, light and color *are* important considerations in photography and to exploit them best, particularly when the levels of both are low, we need to understand something of the nature of each.

■ THE NATURE OF COLOR

When we look at light from the sun (with due care, of course!), the moon, or a light bulb, we perceive that light to be white. But, as we learned in our elementary science lessons, pass that white light through a prism and it breaks into all the colors of the rainbow.

Of course, those with a little more knowledge of optical physics will add some caveats. First, the light from the sun and a light bulb, though ostensibly white in each case, is *not* so. The light bulb, if it is of the common tungsten type, will be decidedly amber in color. The light from the sun tends towards the yellow. This means that when we split each into its constituent colors, the spectra produced will differ slightly.

Second, it's not absolutely correct to talk about the spectrum containing *all* colors. Some colors, such as browns and taupes, to take just a couple of examples, aren't produced by splitting white light. They arise from mixing colors that are not adjacent in the spectrum.

We also have some colors that we recognize individually that are due to the effect of low brightness levels on a particular color. Red gives rise to maroon for example.

But we're straying a little. Whatever color an object is, whether a pure color, a mix of others, or a dark tone, we perceive that color because the object absorbs all *other* colors except that which represents *its* color, which it reflects. A white object reflects most of the incident light evenly and absorbs very little. When we interpret an image—as a print or transparency—the dyes and inks that comprise the image work in exactly the same way.

■ COLOR BALANCE AND COLOR TEMPERATURE

We mentioned that a white light bulb actually outputs a light that is distinctly orange in color. This is not immediately obvious—but compare it to a light source that is closer to true white, daylight for example, and the difference is clear. Viewing it in isolation, our brain is rather adept at automatically correcting this color difference. Only when we see the two side by side can we be more objective.

In fact, *many* of the light sources we consider to be white are not. Light from a midday sun can often be very close to white, but still tends to be slightly yellow. When the sun passes behind a cloud and the blue sky provides the principal illumination, then we get cold, blue light. Toward evening (and before the obvious color effects of sunset) the sunlight becomes more red. We tend to use the term "warmer" for such light, both in photographic and colloquial terms. This is a useful expression, as the most common form of describing the color of white light is as a "color temperature." Calibrated in degrees Kelvin, it provides an easy way to assess the actual color of a light source. The illustration to the right shows the relative color temperature of several light sources, but it's arguably more representative to look at images taken under different light sources (see next page).

Except in the carefully controlled environment of the studio, the color balance and, consequently the color temperature of light, does vary. Daylight in particular varies according to the weather and time of day. This is something that we, in dealing with low-light photography, need to be particularly mindful of. The official "daylight" color temperature, our

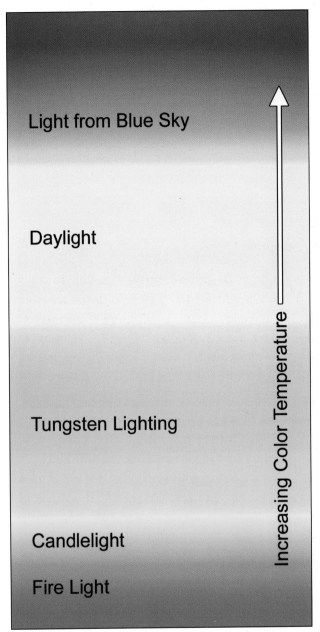

The relative color temperature of several light sources

nominal neutrally white color, actually only occurs for a couple of hours around midday—assuming a sunny sky. Overcast skies become cooler, and clear morning or afternoon skies tend towards the warm. The red component becomes ever more accentuated towards sunset.

In many aspects of photography, it is very important to be able to remove color casts and achieve a neutral color balance. In many of our applications, however, we want to preserve these changes in color—and often even accentuate them.

Portrait taken under ideal, corrected lighting.

With no correction for tungsten lighting, the portrait becomes warm. Sometimes, as here, this can be flattering.

Conversely, when the camera's white balance is adjusted for tungsten lighting and the subject illuminated by color-corrected neutral light, the result is cold.

Fluorescent lighting is hard to compensate for and, without any correction, can product unwelcome green casts.

◾ WHITE BALANCE

Photographic film records a scene along with any associated color balance. Some film types even draw attention to color casts by introducing a slight tone of their own. Digital cameras, borrowing from video cameras, feature a control called White Balance. This automatically neutralizes any color cast in a scene, ensuring that all images are well—and consistently—balanced. In some cameras, this is automatic. You press a button (normally marked WB or Balance) and the adjustment is made. In others, you may need to set the balance manually from the available choices:

Auto (normally the default setting) automatically (and continually) analyzes a scene to determine and apply the best white balance.

Manual lets you set the white balance according to a reference target. This is normally a sheet of bright white paper and is and ideal setting for removing casts in unusual lighting situations.

Daylight sets the camera for an average daylight (notionally sunshine with blue sky and clouds).

Cloudy adjusts to the slightly colder color of a cloudy sky.

Tungsten compensates for warm tungsten lighting.

Fluorescent is sometimes a two-option setting that compensates for cold (greenish) and warm (often magenta) color casts introduced by fluorescent tubes

There is no doubt that this is a genuinely useful tool in general photography but does it help or hinder us in our work? To be fair, even when set to auto, the white balance control will still allow us to faithfully record the color of a sunset. It's good practice to set your camera to auto most of the time—it's easier to correct the occasionally off-color shot than to find that a whole vacation has been recorded with tungsten color balance and you'll need to correct them all!

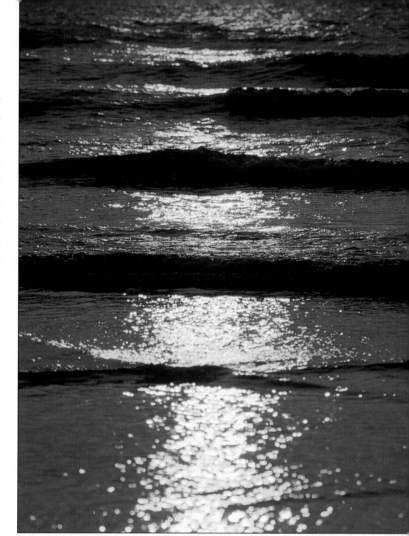

Color balance on evening photos can be very forgiving. This image was created with the compensation set to cloudy rather than auto. This helped to retain and even enhance the warmth of the evening sun.

◾ COLOR IN THE SCENE

Photographing sunsets is remarkably rewarding. It really is hard to take a ineffective sunset image—no matter how hard you try. Overexpose your shot and you may lose a little of the color; underexpose and you could find richer and deeper colors. And the presence of the sun in the scene is almost guaranteed to cause underexposure so success is almost assured!

Sunsets—and sunrises—are compelling. So compelling that we can spend too long watching. To do so will produce some great images, but you'll also miss out on some drama unfolding behind your back. As the sun sets, illuminating the sky with animated color, it is also illuminating the landscape with the same colors. Familiar objects take on a new life as they bathe in this all-too-transient light.

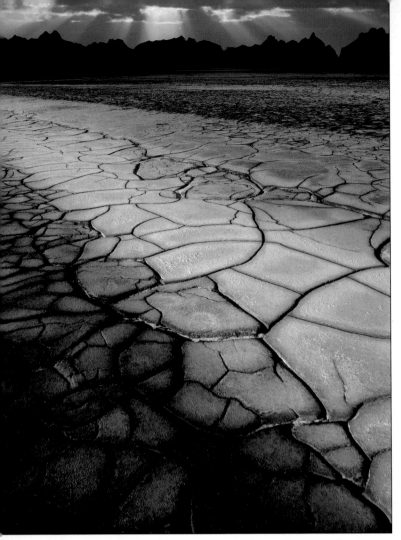

The lake bed scene was actually taken with fluorescent setting—the pink color cast helps here.

Traditionally, before digital technology came to our aid (and I prefer the term "aid" over "rescue," the word some photographers use), we needed to get our exposures spot-on to ensure that we captured the color in extreme conditions. Although we now have the benefit of digital post-production, we should not be unconcerned with precision in our settings, of course, but it does give us the chance to get—potentially, at least—better results. Metering is the key. And that's what we'll discuss next.

■ METERING AND EXPOSURE

Digital photography has made us blasé in quite a few respects. Metering is just one area in which we have been happy to divest ourselves of a fundamental responsibility in creating a good image. We can easily justify leaving things up to our hardware in this case, as metering systems today are incredibly accurate. Simple but effective center-weighted meters that took an averaged light reading biased toward the center of the image have long been augmented by matrix and multi-pattern modes that provide a complex analysis of a scene and adjust exposure accordingly. Some systems can even identify color and distance and compare the metered scene with a database of many thousands of sample image settings. It seems that we really can't go wrong.

But, of course, that argument is overly simplistic. Clever though the exposure system may be, they aren't designed for low-light situations—but that's not to say we should dismiss them out of hand. We need to know how to work with the meters in our cameras, capitalizing on their strengths and understanding their failings.

Center-Weighted Average Metering. Even basic cameras today tend to feature center-weighted average metering, a feature that was once the preserve of sophisticated manual SLR cameras. This type of metering takes into account the light levels throughout the whole of the viewfinder area but biases the reading towards the central area. The center 60 percent of the viewfinder contributes 80 percent of the exposure value. This will give great results for average scenes, like a subject against a moderately bright background with the sun behind the photographer. Bright backlighting or a high incidence of light or dark tones in that central area will fool it, however, and you'll have to apply a correction.

As the light levels fade, this averaging tends to fair rather well. Its characteristics work effectively to deliver well-exposed shots. The even lighting of low-light landscapes mean the weighting has little effect on the image. Minor overexposure will add softness to the scene. A bright sun during sunset will lead to underexposure—but again, this works in our favor, because it produces saturated color.

Multipattern and Matrix Metering. More sophisticated compact digital cameras and digital SLRs feature a center-weighted metering mode, but will normally include the more sophisticated matrix and multipattern modes as well. These measure the brightness at several points through the image and

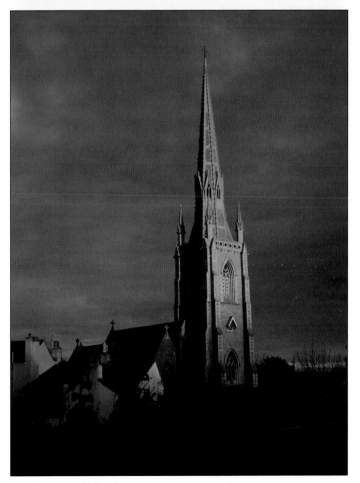

Even though digital photography allows us to compensate for many errors in exposure, it is still important to bracket shots where light levels are potentially problematic. Bracketing means taking shots above and/or below the indicated value. Here, shots have been taken underexposed by 1.5 and 3 stops compared with the notionally correct exposure value. The 1.5 stop underexposure gives the best rendition, a rendition it would have be time consuming to recreate digitally from the "correctly" exposed image.

match the values against a rulebase. If the meter finds that the upper part of the frame is lighter than the bottom, it will make the assumption that this is sky; a darker or different color item may be identified as a subject standing in the frame, and so on.

These systems are remarkably effective and, though they would never admit it, many professional photographers trust these modes for most of their day-to-day photography. In low light, you may find that these modes will work remarkably well. Or, you may find that they can't reconcile what they "see" with one of the exposure rules by which they are calibrated and you'll get an overexposed result.

Merely selecting the main subject of the scene as your metering point won't guarantee great results.

What you will be able to do if this is the case with your camera is to rely on the metering for the basic exposure but then dial in an exposure compensation of –1 or even –2 stops to bring down the overall exposure. This is simple with a digital SLR, but needs a little more cunning with a compact model that doesn't boast exposure compensation. In these cases, you can put a neutral density (gray) filter over the lens. An ND2 or ND4 filter (which give 1 or 2 stops underexposure respectively) should suffice. In compact cameras, the metering is made using a separate window (not through the lens), so these filters will have no effect on the metering.

Spot Metering. Center-weighted and multi-pattern metering systems try to get the best exposure for an overall scene. Employ spot metering and you can get precise exposure for a small element within the scene. This may comprise only 1 or 2 percent of the entire image. This is the most precise method of metering, but it needs to be employed with care. Merely selecting the main subject of the scene as your metering point won't necessarily guarantee great results. You need to ensure that the area you select is a part of the scene that offers average brightness. Take a reading from a shadow area and overexposure will result; take a reading from a highlight and the image will be underexposed.

Experience is the key to exploiting the power of spot metering—and becoming experienced used to take time. With a digital camera, however, we can now circumvent most of this trial-and-error process; we can experiment with different sampling points and see the results immediately. You'll be surprised how quickly your skill develops!

External Meters. When in-camera metering was good, but by no means perfect, many professionals, and quite a few enthusiasts, used external meters. These were more accurate than in-camera meters and gave the photographer the chance to measure the light hitting a subject rather than the light reflected from the subject. A measurement of this incident light can give a precise exposure that is uninfluenced and independent of the reflectivity of the subject.

To be brutally honest, in low-light regimes at least, the metering system in a contemporary camera, with compensation where necessary, will give very good results and will be less hassle than an external device. I'm not dismissing light meters out of hand. They continue to be very useful—if not essential in some circumstances—but for our purposes, hang fire and learn to love the that meter in your camera.

■ EXPOSURE TABLES

Back in the days when we had no alternative to using film, the film carton contained exposure tables. You'd find suggested exposure-time and f/stop settings for daylight, semi-shade, and shade. Settings would be approximate, and using them could lead to minor over- or underexposure. In many low-light conditions, we can use similar tables—and with a greater levels of success, because in these conditions there is no such thing as "perfect" exposure. Rather, there is a range of acceptable exposures. In Appendix 2 (beginning on page 118) I've produced a lookup table for a wide range of shooting opportunities. You can use these settings either as a starting point for your exposures or to check the results from your camera's metering system.

THE NATURAL WORLD

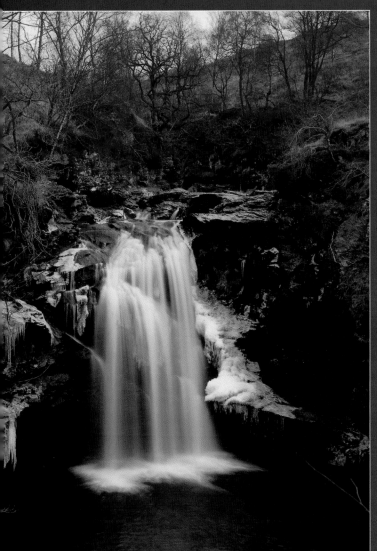

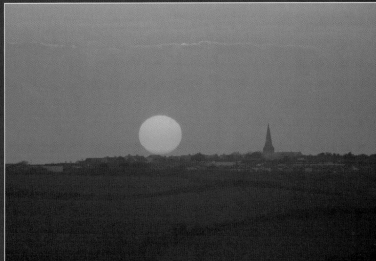

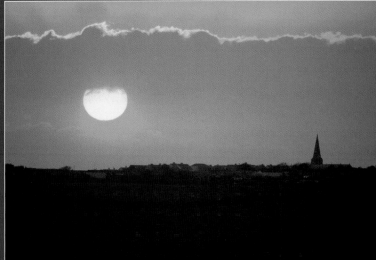

LEFT—In winter, the light levels can be low—but we can use that to our advantage when shooting water. Long exposures allow the water to take on a more ethereal look. RIGHT (TOP AND BOTTOM)—What a difference a day makes. These images of the same scene were shot just a day apart. The characteristics of the landscape can change from day to day; but at the end of the day profound changes occur from hour to hour and minute to minute.

Virtually by definition the natural world is something we need to perceive, observe, and record by means of natural light. For the most part, that will be sunlight—but it's important not to forget there are other natural light sources too: the moon, lightning, and more enigmatic sources such as sky glows, aurorae, and even luminescent bugs!

When we talk about low light we might tend to think more about these secondary sources than we would the sun but the sun—the same object that provides the illumination for the brightest of days—can also provide more muted and subtle illumination. Think about the dappled shade that percolates through a forest canopy,

or the colorful pageant of a fall sunset. Even the ethereal glow of a misty morning. With just a little thought you can probably think of many more.

For many of us, bright sunlight tends to be more of a wish than a reality for much of the year, so the ability to exploit any lighting condition becomes more important. It's fair to say, too, that these times will provide some of the best photographic opportunities.

In the chapter that follows, we'll take a look at one of the most evocative of low-light subjects: the sunset. I've deliberately used sunsets for our first foray into low-light photography—it's one of those subjects where it is hard to go wrong. Even if you just pick up

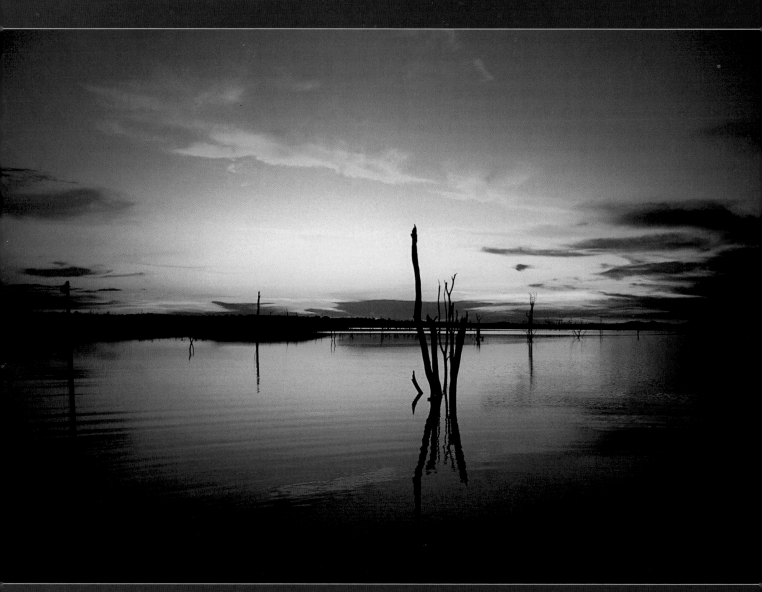

Twilight color is often transient and, almost as often, better recorded by the camera than the human eye. Here, an impressive sunset to the eye has become a riot of color with judicious use of exposure compensation.

a camera and shoot, without any regard to adjusting the settings, you can be pretty confident of getting a shot that looks good. Of course, with a little more effort you'll be getting shots that are great!

Another reason to start with sunsets is convenience. You don't have to travel far to shoot one. Of course, some locations will be better than others. Some will imbue the shot with, say, a romantic air. But even if your westerly horizon overlooks city smog or an active chemical factory, great photos are still possible.

We'll also explore the landscape more generally. As the sun goes down—or, at the other extreme of the day, rises—the light takes on a fleeting magical quality. Add in a little mist or fog and our conventional world is transformed into something more mysterious or surreal.

Even when the sun has set you'll discover that Mother Nature has kept something in reserve. Electrical storms and astronomical phenomena can help make your low-light photography a 24/7 activity. And even if nature does not oblige, we can use the power of digital image manipulation to contrive new landscape scenes and views.

2. Sunrise, Sunset

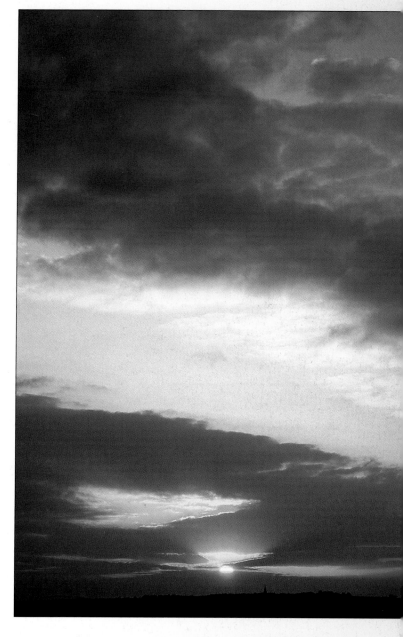

unsets—and sunrises—provide the perfect entry into low-light photography. In fact we could almost go as far as to say they were made for the aspiring low-light enthusiast. Just think about them. You can take them from anywhere in the world. Heavy overcast excepted, you can get results in almost any weather conditions. Rarely do you find a sunset that doesn't at least have promise. Perhaps most useful of all, light levels during most of the sunset (you'll find me using 'sunset' as a generic term here to cover both sunrise and sunset events) can be pretty high, reducing in the uncertainty in exposure.

But, as we'll discover over the next few pages, though it's easy to take sunset pictures, taking really great sunset pictures needs a little more practice and understanding. That's an understanding of the photographic and meteorological science in pretty equal measure. And that knowledge can be repaid. Sunsets comprise a great part of the stock image business: there's always a market for a good sunset and some professional and semi professional photographers' careers have been launched on the back of a few colorful evenings!

◼ THE COLOR OF A SUNSET

Though we can all remember those vibrantly colored sunsets when the whole sky seemed to be ablaze with

Taking really great sunset pictures requires a little practice and understanding.

Times of great volcanic activity, or pollution (particularly that at high levels) can lead to vivid colors and tumultuous effects. Similarly, stormy weather can deliver impressive sunsets, even if the polychromatic effects are only transient.

colors ranging from yellows through reds and even purples, we can probably recall many more such events that were less inspiring. So what makes some sunsets potent (in a color and form sense) and others lackluster?

It mostly comes down to dust. It's the dust in the atmosphere that produces the diffraction of sunlight and, consequentially, the color. This can be natural dust but equally (and ironic for an ostensibly natural phenomenon) particulate pollutants from factories and even automobile exhaust. But these are overshadowed by the effect of volcanic eruptions. Eruptive events can send millions of tons of matter into the upper atmosphere that, before very long, gets carried by the high-level winds all around the globe. The most famous eruption of (comparatively) recent times was Krakatoa, in 1883. Victorian diarists around the world recorded a period of the most spectacular sunsets for eighteen months or more afterward.

It would be something of a waste for us to put away our cameras at dusk until the next major eruption, though, because we can still get pretty good sunsets even when the geological world is in a period of quiescence!

■ SUNRISE OR SUNSET?

Though we have lumped sunrise in with sunset we should qualify our generalization and ask, is there a significant difference—at least in photographic terms—between the two events? The answer is yes! At sunrise the atmosphere tends to be more still, leading to less turbulent effects. Also, pollution profiles tend to show less "active" particulates around in the dawn sky. Finally, moisture patterns can also contribute to a more subtle look in the morning.

But, unless you're a confirmed meteorologist I would challenge you to be able to unequivocally determine whether any of the images here were taken at sunrise or sunset. Of course, sunsets are eas-

ier to photograph. Why? Because you don't have to climb from a warm bed to photograph them! You can hear the enthusiast decrying that statement right now . . .

■ GOOD SUNSET OPPORTUNITIES

So, once again lumping sunrise and sunsets together, we need to ask where (and when) the best sunset opportunities occur.

Time of year has a significant bearing. We find better sunsets in the winter. Partly this is because the sun sets earlier then and partly because the weather tends to be more unpredictable and tumultuous.

The weather, rather obviously, will play an important part in the event. You can get great sunsets with completely clear skies, when wide-angle shots will give you a range of graduated colors across the sky, but the drama seems to come from the clouds. Of

A colorful sunset can generally stand on its own merits, but there's no doubt that following some simple compositional rules helps enhance the image. This bold, centered sunset would be weakened by any foreground distractions. The more delicate post-sunset skies in the second image need some foreground landscape elements to add scale and form to the image.

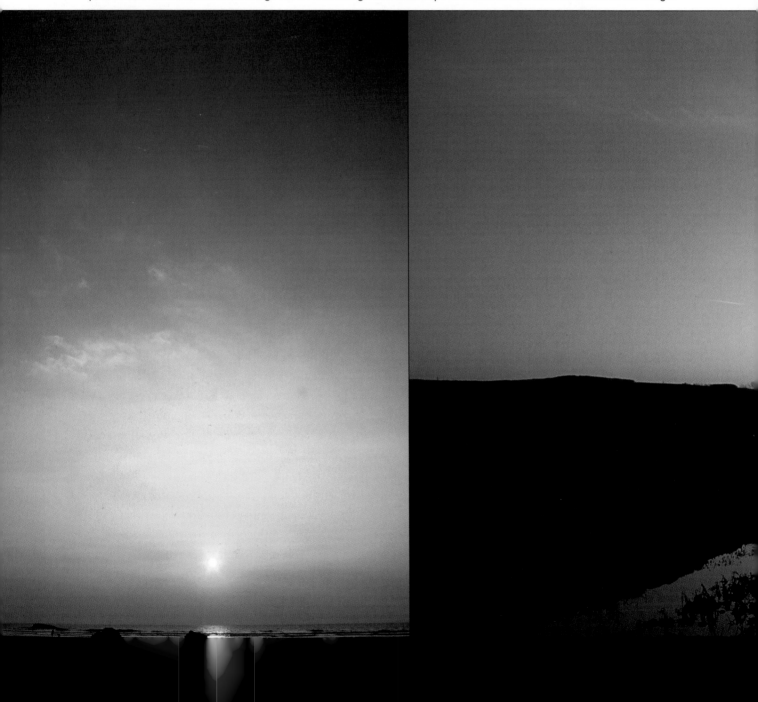

course we don't want too many clouds, but a scattering of them can lead to impressive visual effects. We get shafts of sunlight though the clouds, wide color variation and underlighting—when the setting sun from a very low angle illuminates the underside of the clouds. This can be one of the most impressive, but also most illusive, of sunlight effects.

Location is another important parameter. Sunsets look good wherever you take them but some locations make the sunset look great. The cliché here would be to talk about the desert island (or at least a pseudo desert island) location, with palm trees silhouetted against the sky. But cityscapes and rolling hills can also make for great settings. Do some research. For this, you need to visit some locations (pick ones convenient to your home so you can visit regularly) and look not at the landscape per se, but rather the *form* of the landscape and the *shape* of the horizon. Try taking some overexposed shots, which will give you a flavor of that form.

Think about composition. The sun may look great setting over a cleft in a mountain range or over a picturesque bridge. Then check that the sun will actually set over this point. The sunset position, relative to the photographer, will change daily. In midsummer and midwinter this change is minimal but in mid-

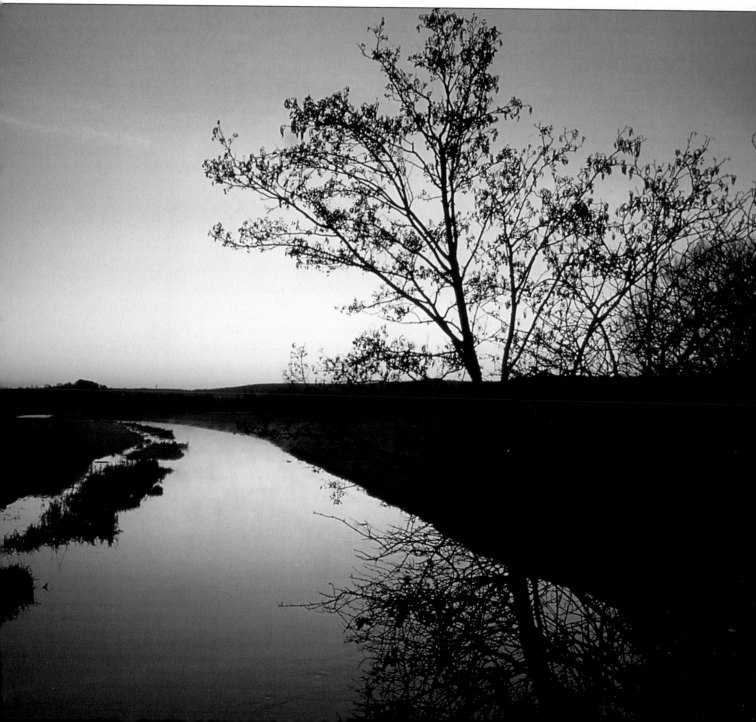

warm light—one that is hard to replicate in any other way. The sky, though, will already be darkening and, if not full of illuminated clouds, will be a deep rich blue.

■ PHOTOGRAPHING THE SUNSET

An advantage of sunset photography is that you have plenty of opportunity to practice. You can do so on any appropriate evening and, if it turns out that the event is a particularly colorful one, so much the better!

Arrive Early. It makes sense to come to your chosen location (be it a National Park or a porch at the back of the house) in good time. Light levels change quickly at sunset. Set your camera up on a tripod. Even though light levels will be pretty high (in comparative terms) for most of the sunset, the use of a tripod lets you concentrate more on the composition and camera controls rather than keeping the camera level and steady. Pay particular attention to getting the camera level. Sunset shots can be the most unforgiving when it comes to getting the horizon line a little off. The smallest tilt becomes obvious.

White Balance. If you are using a digital camera, you'll need to pay regard to the white-balance controls. We mentioned earlier how white-balance settings are designed to automatically remove unwanted color casts from an image. Your camera, thought, can't discriminate between a color cast and a vivid sunset. It will, thinking it is doing your bidding, work hard to eliminate all the color in the sunset in the belief it is a very strong cast!

White-balance features vary from camera to camera. In some cases, they will remove much of the color straight away—no messing around. In others, the on-board processors will acknowledge that the color cast is so strong it must be intentional and will not be so brusque in its color-cleansing operation.

The best, general advice? Take some test shots and check them using the LCD panel. If the colors are just a little suppressed, don't worry. We can attend to this later when we enhance the images. If they are too pale, try setting the white balance to Overcast (usually indicated by a cloud icon). In fact, it can be

Turn your back on the setting sun and you could be surprised at the photographic opportunities. Bathed in the transient light of the setting sun, buildings, and the landscape in general, take on a warm, cozy look.

spring and mid-fall the changes are much more pronounced. It can be really frustrating to have precise composition in mind, a great sky unfolding before you, only to find the sun is setting several degrees to the south!

Think too about the total landscape. We generally regard a sunset photograph as one in which the setting sun features prominently. There's no doubt that the setting sun does form the center of attraction during a sunset but by turning you back on the sun you can get some more great opportunities. You'll find the landscape bathed in an incredible, rich,

fun to experiment with different white-balance settings. Just as no two sunsets are ever the same, no sunset photo is "correct." If you get unusual but visually impressive effects by setting the camera to Fluorescent lighting, don't worry. Enjoy!

Choose a Lens or Focal Length. Choose a lens—or a focal length if you're using a camera with a fixed zoom lens—appropriate to the scene. Wide-angle lenses or corresponding focal lengths are great for capturing sweeping vistas, great cloud effects, and landscapes. But don't be afraid to experiment. Telephoto lenses can help you pick out detail in the scene. Perhaps the last sliver of the sun as it sets or distant landscape illumination.

Aperture. In general, aim to use as small an aperture as feasible—f/8 or smaller. With this you'll get wonderful depth of field, with everything from the middle foreground to infinity—the sun—in perfect sharpness. But don't be afraid to break this rule. Silhouette shots can look great if the focus is maintained on either the subject or the sunset—rendering the other out of focus. Don't be afraid to experiment and twist or break any rules.

Be Careful. Before we go on to take our photographs, a necessary word of caution. We're all familiar with the warnings about not looking at the sun through a telescope of binoculars. Any damage to the eye will be permanent. Staring at the sun through the viewfinder of the camera may not cause permanent damage, but it can cause short term burn-out and be irritating. Using an SLR with a long lens can lead to more serious damage. So exercise caution. Remember that the sun can still be very bright and dangerous even when low in the sky. Don't chance your luck.

◾ EXPOSURE

Like with the preview of color balance, digital photographers are at a clear advantage in that they can instantly see the results of their labors and make any corrections required immediately. How we pity those enthusiastic film photographers who, after witnessing history's greatest sunsets, receive back images that are just plain washed out!

But before we retire into smugness, we still should not put all our trust in the LCD preview panel. It's great for giving us a preview and letting us review the results after exposure but should not be regarded as anything more than a guide. When we load the same images on the computer later we may still find them too light or too dark. Image manipulation can then make up some of the deficit but that doesn't make up for not getting things right in the first place!

So, bracket your exposures. If your camera tells you to shoot at f/11 for 1/30 second (or makes that decision for you) shoot another at f/11 and 1/15 second and yet another at the same aperture but 1/60 second. That's one stop more exposure and one stop less respectively. If your camera uses an autoexposure system, you'll have to get the bracketed results by setting an override (exposure compensation) of +1 and −1 stops.

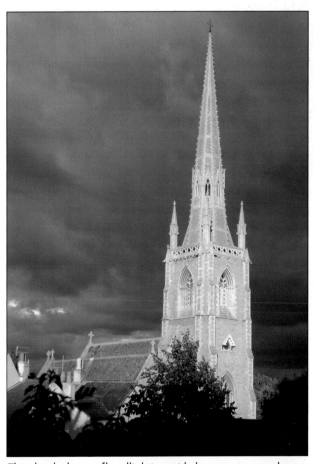

This shot balances floodlighting with the sunset to produce a remarkable shot. In such cases, exposure advice is difficult. You will need to bracket shots, even with a digital camera.

■ SUNSET DYNAMICS

There's no precise moment when a sunset is at its best, so keep shooting. Sometimes it'll get better, sometimes not. A digital camera means you can shoot endlessly (or for as long as your memory-card holds out) and later select the best images. Take the occasional glance behind you to check whether the illuminated landscape is worthy of being featured.

Even when the sun has dropped below the horizon, you'll find there is plenty of intriguing form and color. Now you *really will* need your tripod, as exposure times will be getting seriously long. Take some shots of both the sky and the landscape (bracketing as before) and you'll find something very strange. Colors invisible to the naked eye will appear in the LCD; it's a remarkably warm light that can imbue the landscape with a quality that can't fail to impress. You'll find a digital camera will work better than its conventional stablemate under these conditions, too.

■ ENHANCING THE SUNSET

Sunsets are so colorful that it can seem something of an anathema to suggest that they need further manipulation, but often getting the image just right needs a little work. Here are two ways to make your sunset more punchy.

Unsharp Coloration. If you've used Photoshop or one of the other big image-manipulation programs, you'll probably have come across a feature known as Unsharp Masking. Despite its name it's actually a technique for improving the sharpness of the image in a controlled way. The mechanics of the process involve combining an image with a slightly blurred copy of itself. This helps delineate high contrast areas and, by further enhancing these, increases the sense of sharpness in an image (don't believe anyone who says digital techniques can focus a blurred image—they can only improve the perceived sharpness in the image).

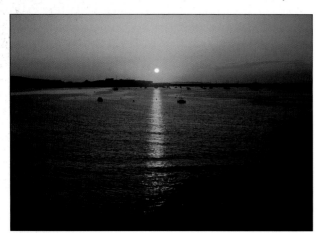

Original image.

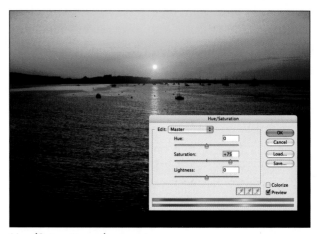

Hue/Saturation adjustment.

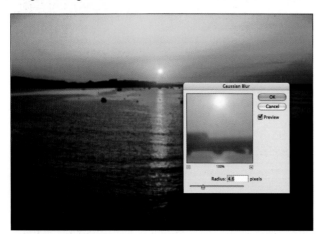

Gaussian Blur filter.

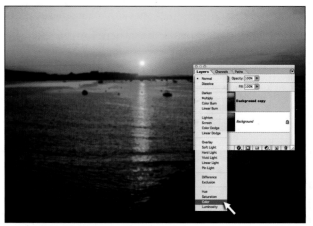

Color Blend Mode.

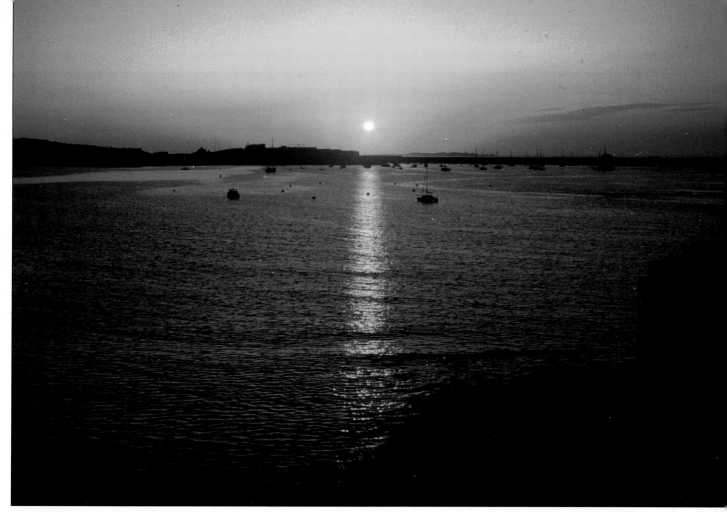

Final image.

We can use a similar methodology to improve the color of a sunset. This is a useful technique—we've dubbed it Unsharp Coloration—to overcome the color suppression that might occur when a white-balance control has been at work.

If you are new to digital image manipulation, you might well stumble (or be guided by the manuals) across a feature called the Hue/Saturation control. By simple manipulation of sliders, you can increase the color saturation slider to get more saturated (colorful) results. The downside to this simple modification is that this process is rather crude and tends to accentuate defects in the image. In particular, you'll generally find that when you boost the color, the image tends to appear very blocked—it breaks into rather obvious blocks of color. In a sunset, where we may have very subtle graduations of color the net result is a very "noisy" picture and one that immediately betrays its digital origins.

Unsharp coloration allows us to boost the color but avoids this blockiness.

Working in Photoshop, here's how to apply the technique. Begin by making a copy of an image by using the command Layer>Duplicate Layer. This produces a new layer in the image, identical to the original (which is called the Background in the Layers palette).

Use the Hue/Saturation control (Image>Adjustments>Hue/Saturation) to adjust the color saturation. How much will depend on your taste and the nature of the image, but add a little too much color, rather than too little. We'll see why later! If you use the zoom tool to get in close on the image you should see that the image has become blocked with color and may have taken on a somewhat artificial appearance.

Now blur this image. Select Filter>Blur>Gaussian Blur. The Gaussian Blur filter allows us to apply a controlled amount of blur by using the slider. Give the image an amount of blurring to totally smooth the color gradients, removing any blocking. Don't worry that the image is now totally blurred—

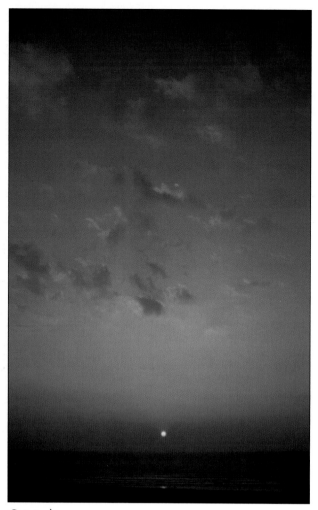

Original image.

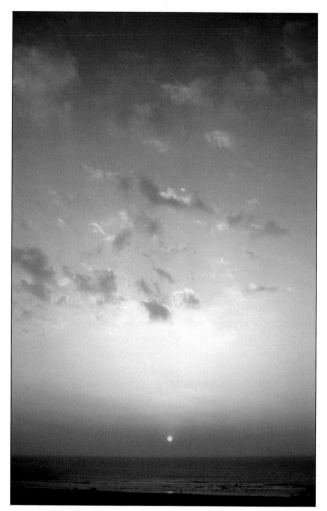

Image with Auto Levels applied.

remember, we've applied this blurring only to the copy of the image.

In the Layers palette, open the Blend Modes pulldown menu and select Color. This control determines how the layer image will interact with the background. In its default state (Normal) the layer is opaque and we can't see the background layer at all. When we switch to Color, the color from the overlying layer is combined with the background; that layer becomes otherwise transparent. You can move the opacity slider if the original effect is too strong.

You will see immediately that the image is sharp but more colorful. But that color has been achieved without sacrificing quality. Though the blurring process tends to smear the color outside its normal boundaries, our eyes tend not to notice this and rather perceive a very colorful image.

Adjusting Levels. The Levels in an image are the amount of tones present, ranging from the purest white through to the darkest black. Quite often, most commonly due to shortcomings in the digital camera or conversion process of a conventional image to a digital format, we lose some of this tonal spread. The result is an image like this, with a good range of color but with no real blacks or whites.

A quick way to restore the tonal range is to use a command called Auto Levels. This will automatically stretch the tones in the image so that the darkest gray becomes black and the lightest tone becomes white. This can work remarkably well, making the presumption that the image contains elements that *should* be black and white.

If we use this on our sunset image, however, we get a rather unfortunate effect. Yes, we have extend-

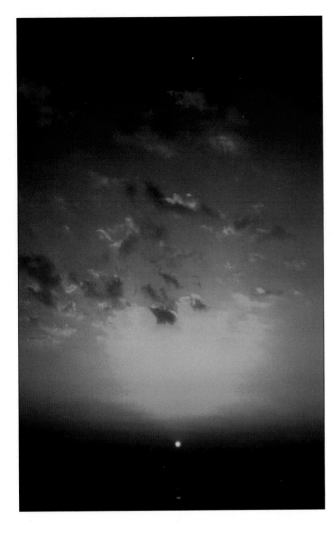

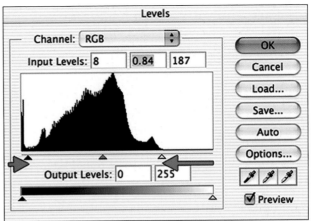

Adjusting the Levels manually (above) produces much more appealing results (left).

ed the tonal range but we have done so at the expense of the color. The effect has been to alter the color in the same way that an in-camera white-balance feature would work, so the color has been de-emphasized. It's brighter and more contrasty but less effective.

For subjects that contain strong color casts and biases we must eschew the Auto Levels command in favor of making a levels correction manually. We can do this by opening the Levels dialog box (Image> Adjustments>Levels) and moving the little sliders beneath the histogram (which represents the spread of tones) towards the centre. You need to place each close to where the graph begins and ends. As you make the changes, keep an eye on how they are enacted on the image. If the result looks too severe, ease the slider back a little. Try moving the midpoint slider a little, too. This controls the appearance

of the midtones in the image. You can lighten or darken the image by moving this just a little.

The resulting image from our manual adjustment of the levels has better tonality and color. We've preserved the delicate salmon hues (which always seem to be the ones that get removed by enhancement techniques) but made a brighter, punchier sunset.

■ LANDSCAPES

Don't quote me but I'd reckon that 99.5 percent of the world's total of landscape photographs are taken in bright sunshine. That's because we like bright punchy colors and there's something uplifting about a photograph taken in bright sunshine. But how many of these photos are really successful in capturing the essence of the location or create an evocative scene? Undoubtedly very few. It's those images—the 0.5 percent—taken in less favorable conditions that, shot for shot will offer the most interesting images.

Professional landscape photographers will rarely be found out in the midday sun—unless on the way to or from a location. They'll tell you that it's the morning, late afternoon, or evening light that is the most flattering for landscape photography. Moreover, they are less likely to shy away from a scene when the weather turns bad. We might all concur that flat overcast lighting is bad, but the deep moody light that manifests only during the most extreme weather is actually very useful in getting great shots.

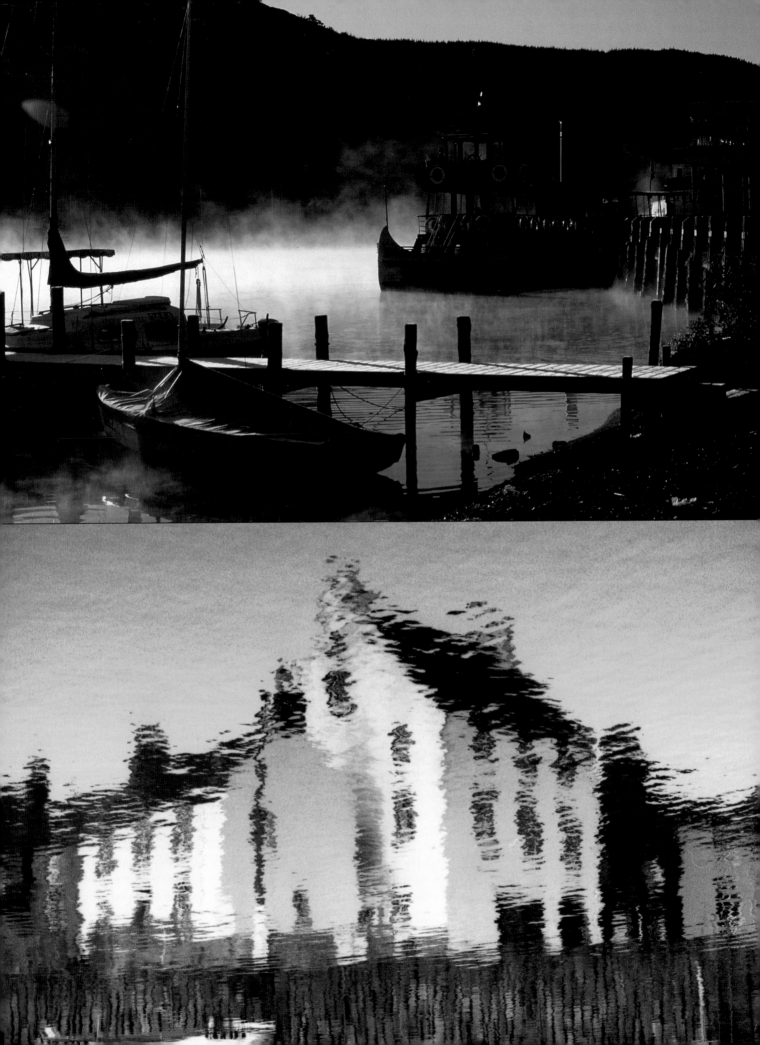

Let's take a somewhat circumspect view of the extremes of weather and how we can best exploit them for our landscape photography.

Morning Mist. The still air that means sunrises tend to be less tumultuous than sunsets also provides the perfect conditions for mist. Mist forms when water vapor–laden warm air meets the cold ground or areas of cold air—usually in depressions or hollows. It's often an ephemeral time; as the sun climbs, the temperature rises and the water droplets that comprise the mist become vapor again and the effect is lost.

The best time to catch elusive mists is spring and fall when temperature gradients between night and day, ground and air, tend to be at their most conducive to their formation. The best place to find mist is in water meadows, at the foot of hills, and in broad valleys.

Mist, photographically, softens outlines and produces muted color. Distance is enhanced because the degree of translucence varies directly in proportion with distance from the lens.

We tend to apply the term "mist" to water droplets that soften rather than obliterate our view; when that mist becomes denser and the visibility is reduced to just a few meters, our terminology changes. We then call it fog. Fog is harsher, photographically, and tends to reduce the landscape to only its most bold forms. This harshness has none of the subtly of mist but can produce remarkable images. Under a blanket of fog even familiar landscapes take on an unearthly quality.

Digital Mist. We can't produce mist on demand, but we can produce the softening effect digitally

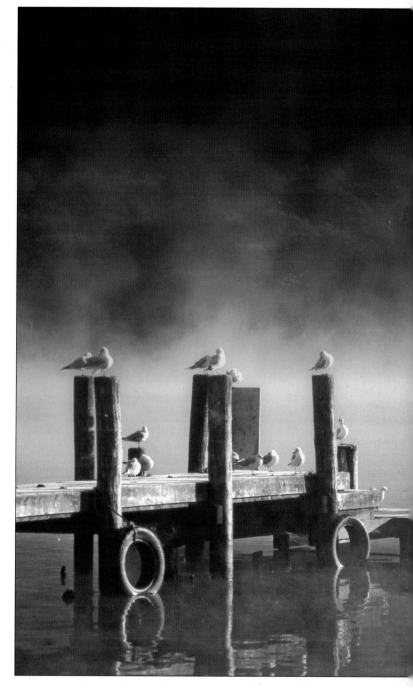

using a technique known as digital soft focus. Soft focus is a technique often produced in-camera using specialized filters and most often applied to portraits. By preserving the overall sharpness yet giving a mistiness to the image, portraits are rendered particularly flattering. The same technique can give a dreamlike appearance to landscapes shot at the extremes of the day.

To create digital soft focus, you'll need to create a duplicate layer of your image. Use the command

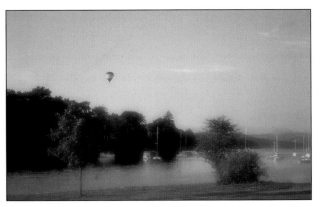

LEFT—Here's a morning landscape that would be uplifted a little if we were lucky enough to have found the morning just a little misty. RIGHT—Digital soft focus has given us the chance to add that mist. And unlike real mist we have the opportunity (by varying the amount of blurring, or changing the Opacity level) to control the amount of softening.

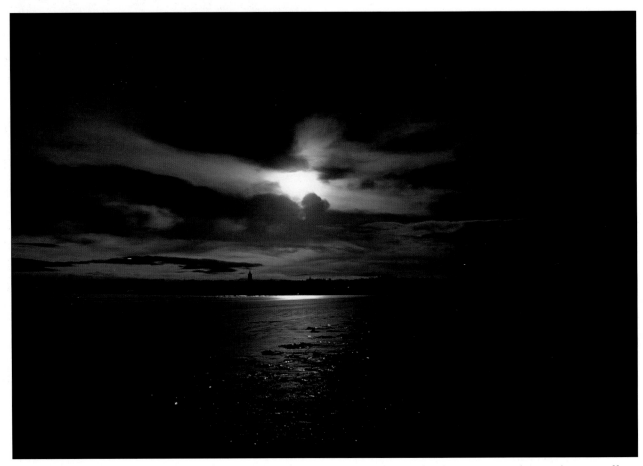

By deliberately underexposing this shot of the sun breaking through some heavy clouds we get a much more dramatic effect. We could further enhance the effect by applying some digital dodging and burning later.

Layer>Duplicate Layer. Blur this layer using the Gaussian Blur filter (Filter>Blur>Gaussian Blur). Finally, using the Opacity slider on the Layers palette, reduce the opacity of the layer to about 60 percent. This allows the blurred layer and the sharp-focused background to coexist. The result: soft focus.

Bad Weather. Okay, so "bad weather" is a rather loose term. For our purposes, the best bad weather (if you excuse the bad English!) is stormy weather.

And storms where the occasional bit of sunlight breaks through are fantastic. The high contrast between clouds and sunlit objects make for terrific shots, but you'll need patience. The patterns of light and dark on the landscape never seem to move as fast as the clouds in the sky and you may have to wait for some time until you get light that is just right or until a particular feature is highlighted.

The big changes in brightness are also tough on your camera's exposure meter. It makes good sense to bracket your exposures as I suggested for sunsets. It can often be the shot that is nominally overexposed or underexposed that provides the best image.

Dark Locations. It's not just dark weather conditions that can give mood to a landscape. Some locations are equally effective at doing so. Deep ravines tend to be penetrated by sunlight only for short periods on the best of days, while forest canopies tend to

RIGHT—Under tree canopies and in the green lanes that bisect them, the morning mists linger on later into the day, as seen in this mid-morning shot. But the image is a little too blue still. BELOW—Applying a warm tone using the Color Balance command improves the overall tonality yet it is not detrimental to the lush foliage. You can improve the image further by altering the levels (see page 31). In particular, move the midpoint slider a little to the right to darken the midtones in the image. How could we make it even better? A couple of walkers in the near right foreground would be ideal but I was, sadly, alone.

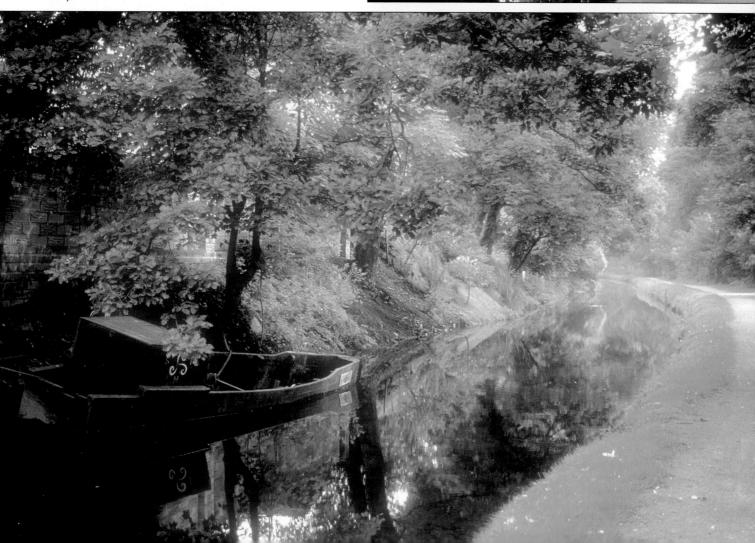

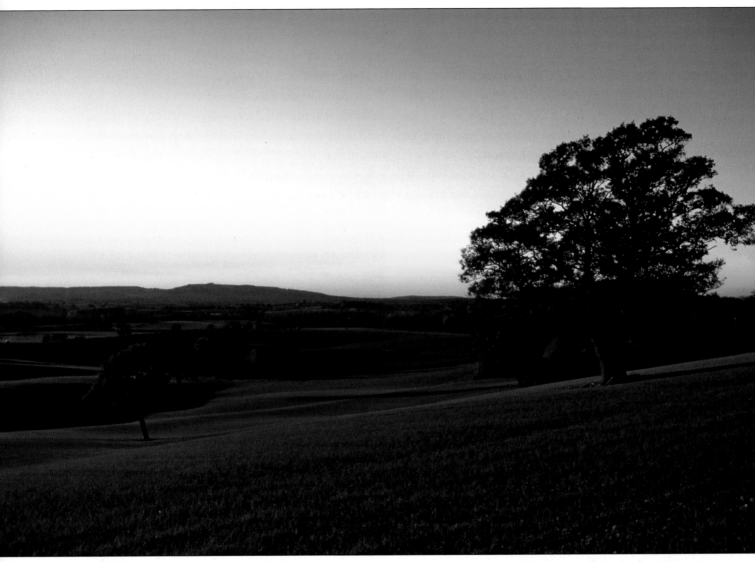

Some color casts aren't detrimental. The strong amber cast here, due to the setting sun reflecting from light clouds, adds to the drama and impact of the shot.

break up any incident light to produce a unique dappled shade.

In both these conditions you'll find that the quality of the light is such that it tends to be more blue than in the open landscape; this could be one occasion where you can exploit the white balance of your camera by switching to the Overcast setting. Or, if you have some of those good old photo filters, slap on a warming filter.

Don't worry if you can't warm up the color balance in-camera. Photoshop gives us an easy way to warm up a scene. When your images are loaded on the computer choose Image>Adjustments>Color Balance. Move the slider toward the red a touch to

warm the image a little, a touch more to deliver an even warmer result.

There's no right and wrong about the amount of warming. If it looks right, it probably is right!

▣ A PERFECT MOON

An evening landscape with the moon suspended serenely can be truly evocative. Successfully visualizing this scene can be difficult, but with a little help from a master we can contrive some amazing scenes.

For many landscape photographers, Ansel Adams has been both inspiration and idol. At a time when photographic technology was, compared to today, crude, he successfully achieved what many of us

strive for today. Images that attain perfection in terms of composition and, more significantly for us, exposure. This applied even to problematic subjects. Consider one of his most famous images, *Moonrise over Hernandez*, a beautiful landscape with a delicately lit moon rising over it.

Quite a few photographers, inspired by this scene, have been motivated to create a similar scene themselves. They would wait patiently for the moon to be in the right position (more of a problem than getting the sun in the right position for the perfect sunset) and take the shot.

Disappointingly, the moonrise over Atlanta or Pasadena never seems to have the same impact as the same event over Hernandez. Let's take a closer look at what Ansel did and see if we can get any pointers.

Ansel described the day he photographed Hernandez as disappointing—he'd tried to capture some shot he'd previously visualized but been ultimately unsuccessful. He was on his way home when a side-ways glance from the window of his car revealed the scene that would feature in the photograph. He quickly unpacked his kit and, with the help of his colleagues, was ready for action. It was then that he realized he did not have his exposure meter.

He knew the right exposure to capture the moon and exposed—using his famous "zone" system—for this. One second at f/32 on ISO 64 film using a 10 x 8-inch plate camera. He backed this with some notes on how he needed to process the film back in his darkroom.

Ansel planned to take a second shot but found that the sunlight was gone and with it some of the elusive elements that made the shot so memorable.

It was in the darkroom that the creative process continued. Here, Ansel ensured that the subtle illumination of the landscape and, in particular, the sunlit cruciforms, were well matched to that of the sky and moon. The task was long and complex, with different parts of the image being given slightly differ-

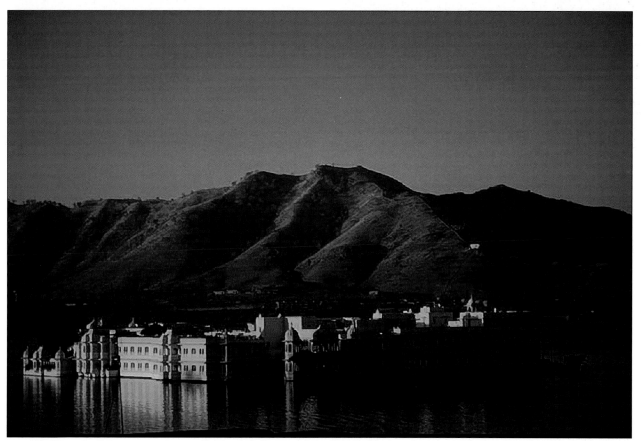

This landscape will be ideal for placing an image of the moon into. The sky is comparatively bright and a conventional montage with a lunar image would give unsatisfactory, unnatural results.

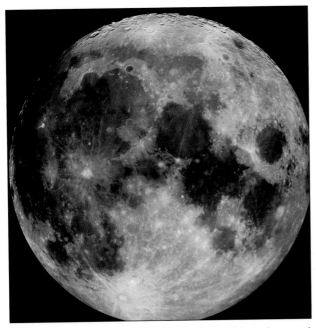

Here's a shot of the moon taken with a 400mm lens and Fujifilm S2 digital camera. In 35mm camera terms, this lens has an equivalent focal length of 600mm.

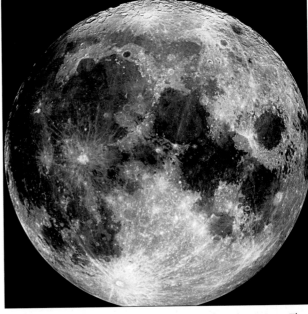

I cleaned up the image of the moon by desaturating it. This removed anomalous color. I also sharpened the image using Unsharp Mask

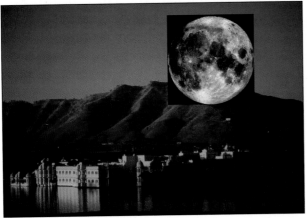

Before changing the blend mode, here's the montage. At this stage, I can use the transform tools to change the orientation and size and use the Move tool to position the moon precisely to support the composition.

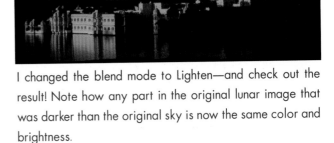

I changed the blend mode to Lighten—and check out the result! Note how any part in the original lunar image that was darker than the original sky is now the same color and brightness.

ent exposure in the darkroom by careful use of masks over the selected parts of the image. It was truly an image crafted and not just taken.

What would Ansel have made of the opportunities of digital photography? As our timelines never crossed I can't say for sure, but as photographic artist, I've no doubt he'd have embraced the tools.

We are fortunate in that we can use some of our digital tools to emulate Adam's techniques. Here's a simple way to give any landscape—not even evening or night shots—a perfect moonrise sky. To do this, we need to first take a photo of the moon, exposing for the moon itself. You could use a telescope for this if you have access, or a long telephoto lens, or even the telephoto end of your camera's built-in lens. The only difference will be the scale. Bracket your exposures to ensure that you get a well-lit but not glaring image of the moon.

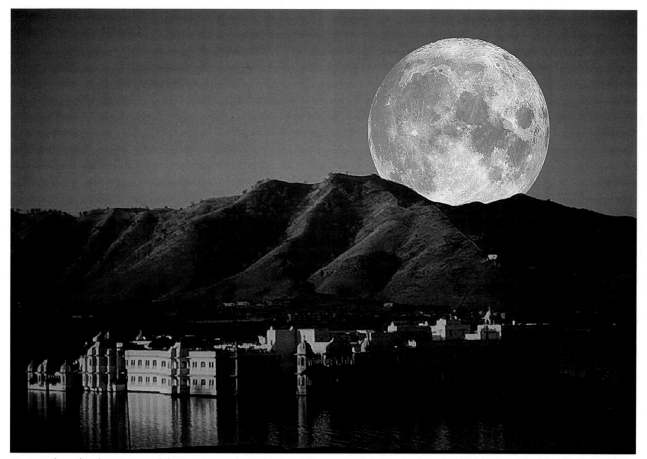

To complete the deceit, I used the Eraser tool to rub away that part of the moon that should be concealed by the mountain.

Take a look at the moon in the sky at twilight—or even in daylight—and you'll see that no part of the moon is darker than the sky. The darkest, shadow parts of the moon take on the color of the sky, whether twilight mauve or midday blue. As a result, if we simply transpose the image of the moon we've taken onto another twilight shot, we end up with a totally implausible result.

To produce a convincing image we need to use blend modes. These are something we'll be taking a look at in detail later, but here's how they can come to our aid now. As you'll see the process is remarkably simple; you don't even have to select or cut out the image of the moon before placing it in the new sky!

Copy the image containing the lunar image onto the landscape. Unless you've got the scale right in the first place you'll probably find the moon is too large or too small for the scale of the landscape. You can use the Transform tools (Edit>Transform) to alter the scale and position. Don't worry that the moon image has obliterated at least part of your landscape scene.

Now, in the Layers palette, open the Blend Modes pull down menu and select Lighten. Instantly you will see the dark background of the lunar shot disappear. More significantly, the moon now appears set in the sky with no part darker than the sky itself. This is just as we might expect were we to take the shot conventionally. Except, of course, to take this shot in one go would require a lot of luck and expertise at the shooting stage (à la Ansel Adams) and much work in the darkroom. Even then, we could not be sure that the results would be as good as we could engineer digitally.

■ LIGHTNING: NATURE'S FIREWORKS

Photographing atmospheric phenomena can be amongst the most rewarding of low-light photo activities. It can also be one of the most frustrating.

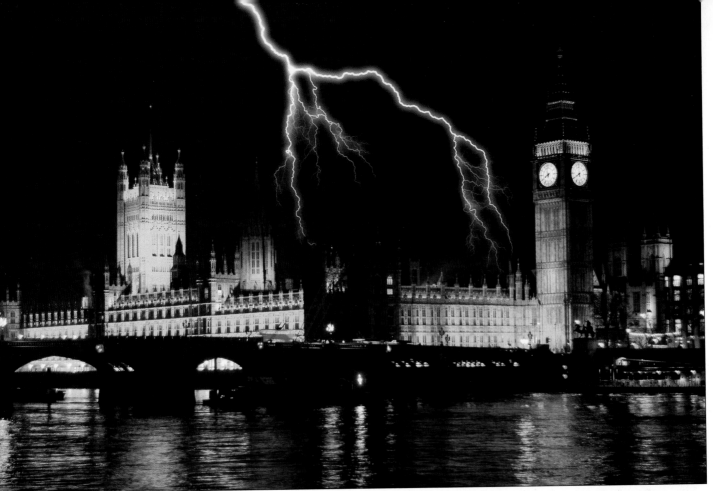

ABOVE—A sudden lightning bolt adds depth to this cityscape, even though it was not anticipated at the time of shooting. RIGHT—Lightning, so conventional wisdom proscribes, is white. Shot through storm clouds, this distant display takes on a red/amber hue.

For all of man's attempts to control and tame nature, predictable it isn't. I, for one would give our weather photographers (almost) as much respect for their determination and perseverance as I would their images.

Lightning is, in visual terms, one of the greatest weather spectacles. It can strike anywhere (and, contrary to the old adages, it is quite likely to strike the same place twice) and is comparatively easy to photograph. Clearly, it helps if you live somewhere where storms are commonplace and can, with all due deference to the vagaries of nature, be regarded as regular visitors.

Safety First. Before we begin, here are a few timely safety remarks. Spectacular it may be, but lighting is also extremely dangerous. Observe sensible safety precautions.

In particular bear in mind that lighting takes the easiest path to earth (or *up* from the earth, if we are being scientifically pedantic). That easy path isn't necessarily the highest point in the neighborhood, it's the one that provides least electrical resistance. A tall metal or carbon-fiber tripod? Perfect! The best shots will be when the storm is some miles away, so when it gets close, retire to safety. An automobile on open ground (away from trees) is a good place to weather the event.

Watch you camera electronics. Even if a storm is a short way off, the electrical disruption can affect the delicate electronics in your camera. Turn the camera off as the storm approaches.

Most of all, remember that an electrical storm is unpredictable. Storm clouds can extend in all directions for several miles and the dormant part above you might spring into life with little warning.

Grabbed Shots. Preparation is the key to great lightning shots, but don't miss that opportunity for grabbed or impromptu shots when the opportunity

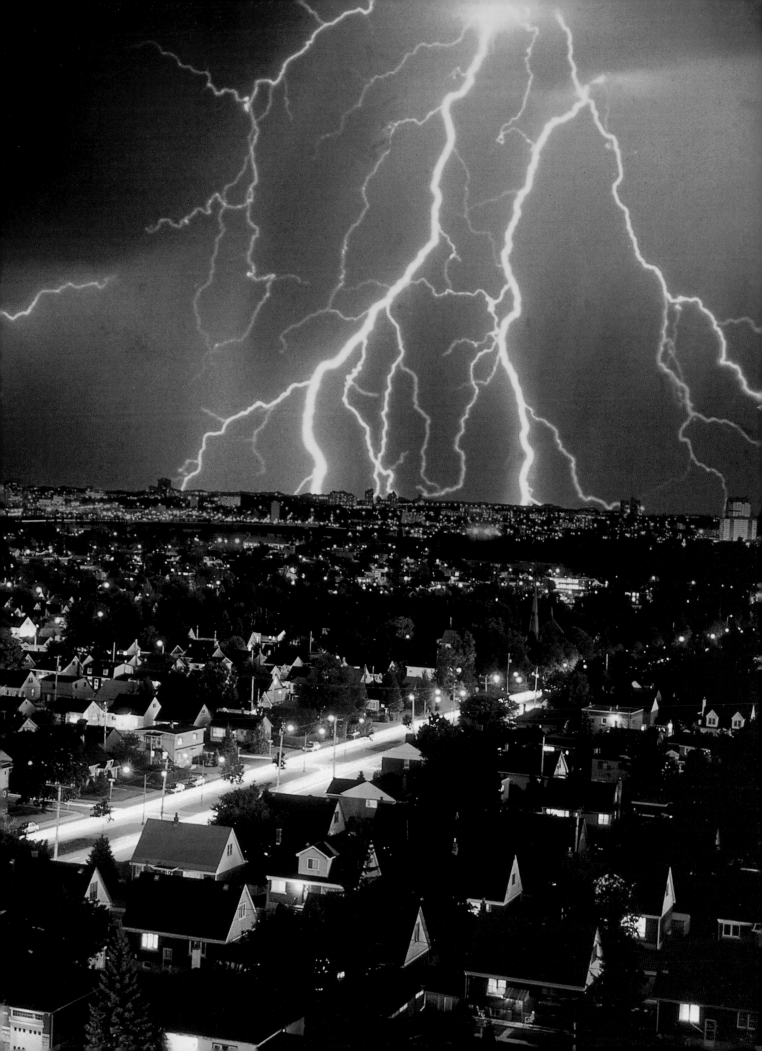

presents. If you find yourself faced with these amazing fireworks, point your camera toward the heart of the action. Set up for long exposures and set the camera to f/11 (for ISO 200 film, or digital equivalent speed). Hold the shutter open. How long you do so will depend upon the level of activity. Very potent storms can output so much energy in the form of light that your images can quickly become overexposed. Just shoot away with different shutter times and enjoy! The results may not be perfect, but they will be an impressive record of the event.

Time of Day. We've presumed to this point that you'll be shooting at night. At night, it's perfectly feasible to keep the shutter open for extended durations without fogging the image. Even if you're living in a brightly lit suburb, the small aperture will restrict fogging for shots of several seconds. Planned daylight lightning photography is almost impossible. You'll need short exposures and the chance of hitting the strike during the open-shutter time is minimal. Even under favorable conditions, with dark, storm-cloud laden skies, exposure times will still be brief and your chances are limited. Avoid such frustration and wait for nightfall!

We mentioned above some optimum settings for recording lightning at night. Like all such rule-of-thumb determinations, these values are rather approximate. Depending on distance and level of activity, you may find that the results are under- or overexposed. In practice, this means that you'll find you record just the shaft of light (in the case of underexposure) or your images feature broad, featureless swathes of light (overexposure). At the risk of sounding defeatist, the best way to get great shots is to bracket your exposures.

Use this simple calculator (below) to evaluate the best average exposure, then bracket (up to ±2 stops)

around this. Calculating distances are problematic at the best of times, but base your calculation on the time delay between a lightning strike and the thunderclap. It takes the sound five seconds to cover one mile and around three to cover one kilometer.

Clearly, with such small apertures it might be necessary to use neutral density filters (yes, at night!) to accommodate the full bracketing range. Alternately, switch to an ISO 100 or ISO 50 setting and reduce the f/stop settings by 1 or 2 stops respectively.

At dawn and (more often) dusk we have a chance of capturing some of the incredible sky colors that develop when the light from a storm cloud combines with the increasingly reddening daylight. To get best results here you need a fairly active cloud and a reasonable amount of luck. If light levels allow, meter off the darkest storm clouds and then reduce the aperture by one or two stops (again, it is hard to be precise, so bracketing is advised). Adjust the aperture and exposure time to keep the exposure value constant but to allow exposures of four seconds—or longer. Fire away!

Do bear in mind that light levels during a storm change dramatically over a short time. When you combine this with the sun setting or rising, changes will be even more pronounced, so ensure that you keep an eye on the exposure, reading and recalculating as often as possible.

Finding a Storm. To get the best from this natural spectacle you need a little experience and understanding of atmospheric physics. You'll need to understand a little about thunderstorms, the best vantage points (both locally and—if the bug bites—worldwide), and a good routine for photographing the events.

Thunderstorms are a lot more prolific that we imagine. The planet faces a constant barrage with

DISTANCE (MILES)	DISTANCE (KILOMETERS)	F/STOP SETTING (AT ISO 200)
5	8	f/11
4	6	f/16
3	5	f/22
10	16	f/5.6

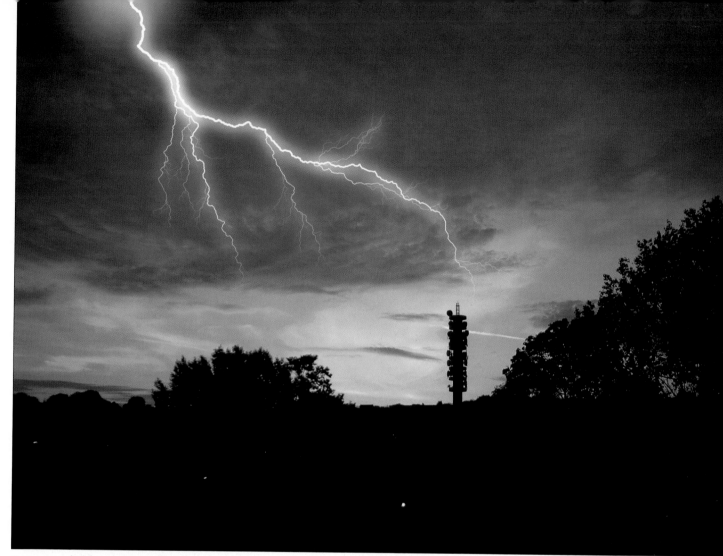

Evening twilight is often too bright to record storms—the chances of catching a bolt when the exposure is made are small. But when you're successful, the results are impressive.

hundreds of events discharging trillions of volts of potential onto hapless parts of the earth's surface. And it's not just flashes between earth and cloud. Atmospheric physicists have recorded bright shafts of light—called sprites—emanating from the top of storm clouds and reaching many tens of miles out towards the edge of space. It seems the more we discover about thunderstorms, the more there is to learn. But for now, we have more pertinent needs. What makes a good thunderstorm? When that first rumble of thunder breaks the evening silence there are few clues to how photographically useful the event will be.

Though statistics could be misleading (as they tend to be produced from worldwide averages) the majority of storms don't provide great photographic opportunities. The downfall of many is that too

much rain accompanies them. This is not just uncomfortable for shooting in it scatters and dissipates the light from the lightning giving hazy and indistinct results.

Fork lighting—the type that interests us—isn't always produced either. Many storms emit a white-over of sheet lightning. This is more like an enormous electronic flash discharge.

For the best early warning check the most detailed weather forecasts you can for your area. (The Weather Channel and Weather.com are ideal starting points.) Look out for advice on active storms crossing your district—especially ones that precede a cold front, as these tend to be very active with average times between flashes of around one second.

For the most dependable storms move to the north coast of Australia or the Gulf Coast. Here,

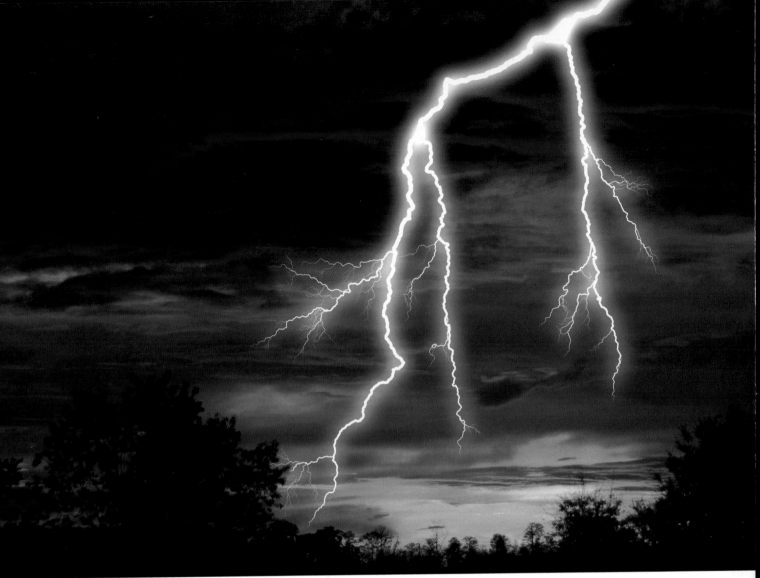

Color in the sky adds interest to the scene. Here, it was enhanced using the Screen blend mode in Photoshop.

evening storms perform almost on demand. In the former case, sea-front restaurants time their meal sittings to best take advantage of the backdrop!

Position. It's not just realtors for whom "location, location, location" is a mantra, it's ideal for the weather photographer, too. Few of us are lucky enough to have a home that opens out directly onto an appropriate vista (but if you do, let me know!) so that means that we need to travel to an appropriate location. "Appropriate" is emphasized here, because we don't want to travel just to a location that has good storms, we need to position ourselves so that the storm fits with the conventional photographic rules—as far as possible—of composition. Like sunset photographs, the best images don't rely on just the events taking place in the sky. The landscape and horizon line are also important.

Bear in mind too the no-nos at the time of storms:

- Avoid hilltops and escarpments
- Avoid open spaces (particularly prairies)
- Keep away from trees and power lines
- Keep away from electrical equipment
- Take cover in an automobile if necessary
- Be sensitive to electrical fields: feel any tingling? Take cover

Taking Shots. Preset your camera. You can save much time in configuring your camera (and the possibility of losing too many opportunities) by making sure your camera is set up in advance. Set the camera to B or T (bulb or time) exposure. This will ensure you have control over the duration of the shots. Preset the camera to the right aperture. If your cam-

era has an autobracketing mode, be sure you know not only how to use it but how to activate it in the dark! Unlike astrophotography where you need to avoid exposure to bright light (which has a devastating effect on your night vision) there is no issue with using a torch or flashlight to help set the camera.

Cameras that don't have a B setting often have a long-exposure option; usually this will give exposures of up to one to two seconds at low light levels. In these cases, you should be okay during very active storms, but you'll need to sort through the resulting images and be prepared for more than half to be completely black.

Whatever camera you use, remember to prefocus the camera at infinity. There's nothing more frustrating (particularly with autofocus SLRs) to hear the focus motors whir into action, searching for something to focus on in the gloom! As to which lenses are best, it will depend on the scope and range of the storm. Wide-angle through to intermediate telepho-

The instantaneous nature of lightning is obvious here: there is slight blurring due to the time exposure (and an unsteady camera mount) but the bolt is sharply defined.

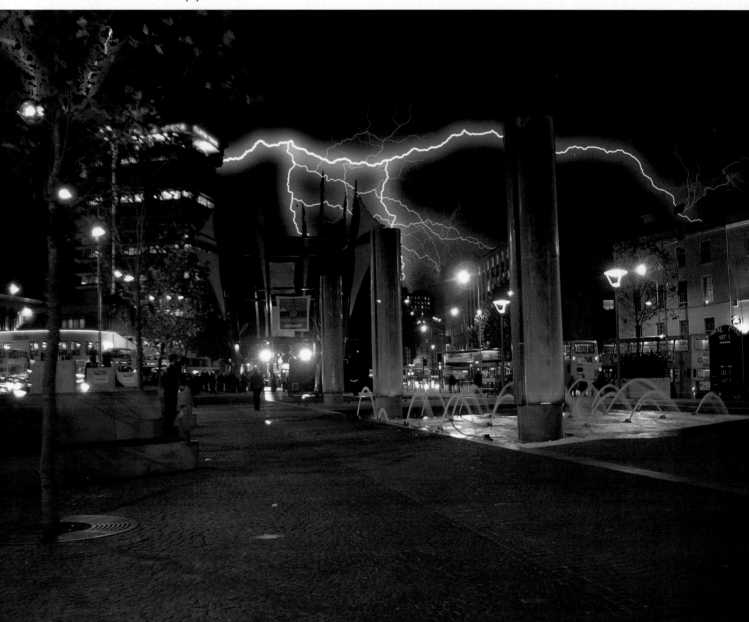

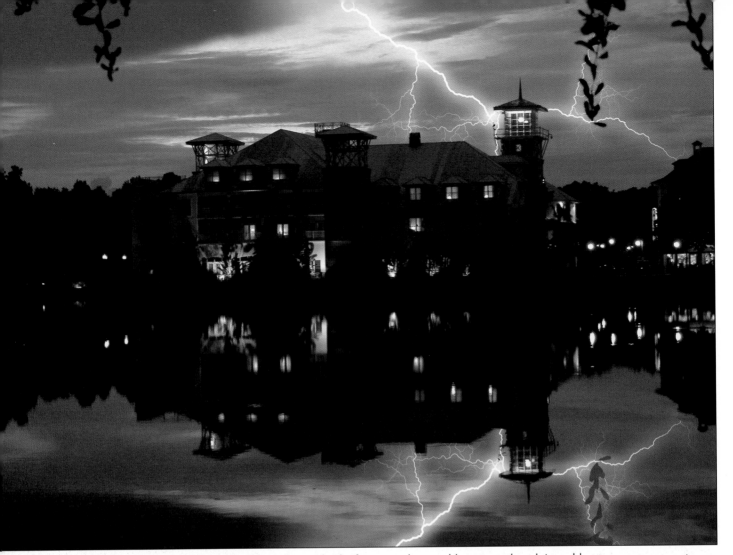

Lightning over water gives you twice the result. The foreground tree adds impact, though I would not encourage you to use such a vantage point during a storm!

to focal lengths will be best—a 28–135mm zoom (35mm equivalent focal lengths) will be ideal and very convenient, particularly since we don't need wide apertures.

And, of course, use a tripod at all times.

Finally, keep plenty of spare batteries with you. Time exposures, in many cameras, put an enormous drain on the batteries and you could find that, after precious few images, you start getting low battery power warnings.

Summary. The intermittent nature of lightning, the potential dangers, and the sporadic appearance often conspire to drive people away from considering it but, as we've seen, it can be simple to get great results. Don't expect to get it right the first time, but perseverance will pay off. And, boy, with the potential for so many wasted shots, that hard earned cash

you spent on a digital camera suddenly seems a solid investment!

☐ ASTROPHOTOGRAPHY

Astrophotography is a rather specialized but highly developed branch of low-light photography. Here, we are dealing with light levels that can vary from bright, the full moon for example, through to levels that are darker even than conventional nighttime photography. As a complete aside, it was the need to record very low light levels accurately and overcome the deficiencies of film emulsions at low levels that helped develop digital photography. In the late 1970s the precursors to contemporary CCD sensors worked by counting the individual photons of light that arrived at the sensor giving accurate—and proportional—light level readings.

The specialized nature of this genre does mean that, for the most spectacular of results, you need to invest in potent and very role-specific hardware that has little application elsewhere—but that doesn't preclude us from getting nice results with more modest resources. If you are prepared to forego the opportunity of photographing the delicate shading on Mars or the detailed filamentary structure of the Orion Nebula, there are some great opportunities.

Shooting the Moon. We have something of a skewed perception of the moon, in photographic terms. We all generally perceive it to be larger than it actually is. Take a photo of the moon with a camera and standard lens and you'll find it reduced to a small speck, probably somewhat smaller in size in the image than streetlights. In fact, to fill the frame of a digital SLR camera, you'll need a lens of a focal length between 600mm and 1000mm. A more mod-

To fill the frame of a digital SLR camera, you'll need a lens of a focal length between 600mm and 1000mm. Thanks to David Hughes, who provided the telescope and monitored the drive controls as I took this photo.

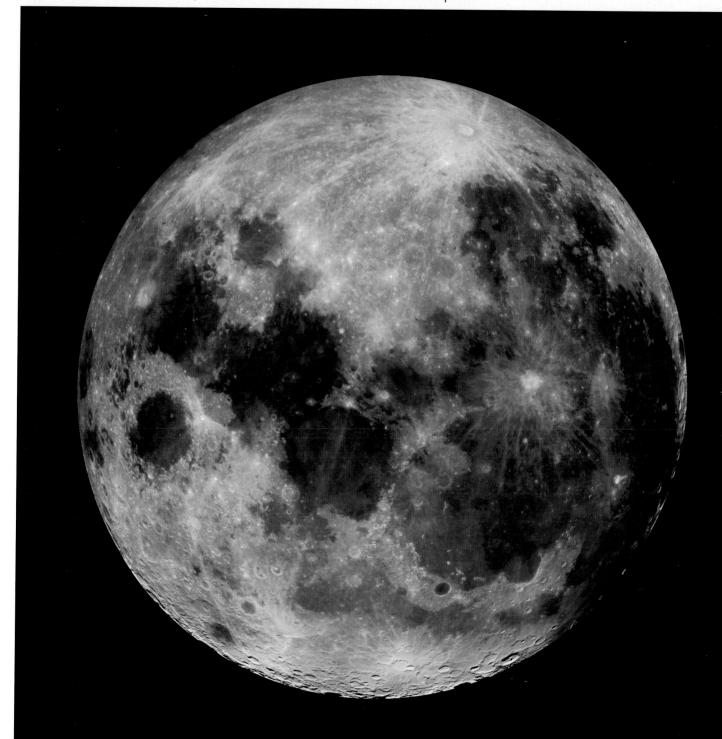

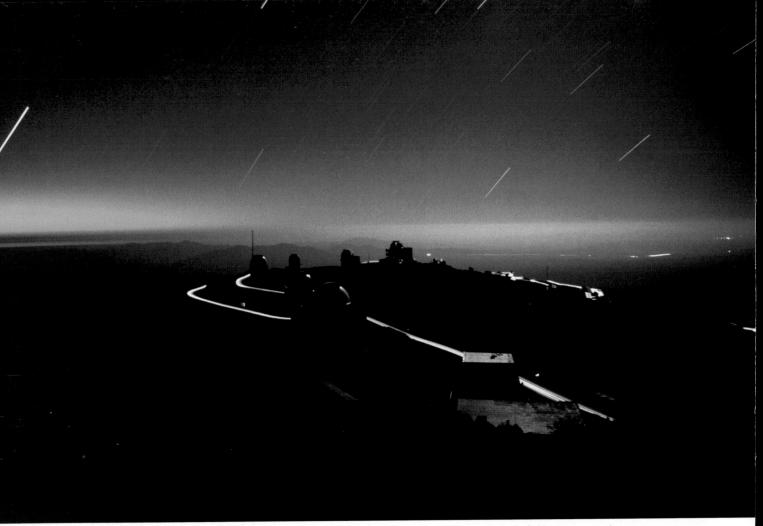

This shot was taken from an astronomical observatory high in the Andes. The particularly dark skies mean long exposures can be successfully recorded without fogging. Thanks again to David Hughes for providing the telescope and monitoring the drive controls as I took the photos.

est 300mm lens will give you an excellent image for including in landscape montages—one of the more pictorial uses of lunar shots, that we use on page 36.

In terms of exposure, the brightness of the moon changes dramatically depending on its phase. A well-exposed shot of the full moon needs an exposure of around ½₂₅₀ second at f/8 (ISO 100 equivalent), but you'll need to open the lens by one or two stops to get an accurate rendition of the quarter moon, and extend the exposure further for a crescent moon.

Star Trails. Though the obvious motion of the sun through the day alludes to earth's rotation, taking photos of star trails is a more interesting way of seeing this motion. As the earth turns, so every star and visible planet in the sky will describe a circle or arc around the north and south celestial poles.

Recording star trails is best done with conventional cameras and, ironically, older, mechanical models

are best. We need to take exposures that last for twenty minutes through to, say three hours. Digital camera don't deliver good results over long exposures and tend to suffer from massive power drain. That's assuming (and it is something of a big assumption) that your camera allows time exposures—it'll need to have a "B" setting.

Even some of the latest film cameras suffer from the same power issues—using considerable power keeping the shutter open. Hence, that old mechanical model is ideal.

Set your camera pointing towards the north or south celestial pole for best results; this is due north and some degrees above the horizon for those of us who live in temperate latitudes (the actual altitude of the pole is 90 degrees minus your latitude).

Load the camera with slide film (200 or 100 ISO) and use a lens with the widest aperture and field of

view. A 28mm f/2.8 would be ideal. Shoot test exposures from, say, ten minutes through to one hour. The best time will be determined by ambient conditions—bright city lights will limit exposures to short durations while in dark-sky conditions you can extend your exposure durations further.

■ THE CHEAT'S GUIDE TO LIGHTNING AND ASTROPHOTOGRAPHY

Our discussions on lightning photography and astrophotography have tended to place the emphasis on the photographic recording of events. Once captured, the photographs can be considered for their graphic, artistic, or reportage significance.

But if our aim is to take photographs for artistic purposes, do we need to be so precious about the authenticity? Though the argument may be a close-run thing, I'd say no.

So where is all this leading? Well, digital manipulation gives us the opportunity to fake both lightning and certain astrophotographic elements in our images. Say you have a favorite night scene and you want to add a star field into the currently featureless sky. Is it cheating to do so? Yes, but if it makes a good picture better? Let's leave any morality to one side and look at how we can achieve such effects.

For both lightning and astrophotography, we'll be using filter plug-ins. These apply a range of effects to a digital image, such as making it appear as an oil painting, pen drawing, or distorting it out of all recognition. Of special interest for our purposes are two filters.

All that Glistens. Glitterato, from Flaming Pear Software, is designed to produce random and convincing starfields. You can add nebulae, star clouds, vary the number, magnitude, and type of the stars virtually—ad infinitum. Once you've created your sky, you can then paste it into your image to replace an existing sky.

With a modest astronomical telescope (such as those manufactured by Meade or Celestron), it's possible to record deep-sky nebulae like this. These shots require that the telescope and camera precisely follow the objects being recorded.

A new sky created in Photoshop.

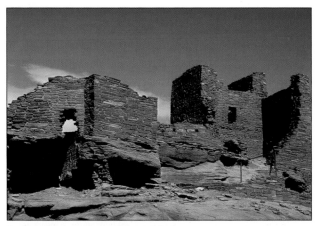

Image the new sky will be added to.

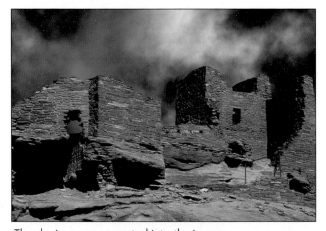

The sky image was pasted into the image.

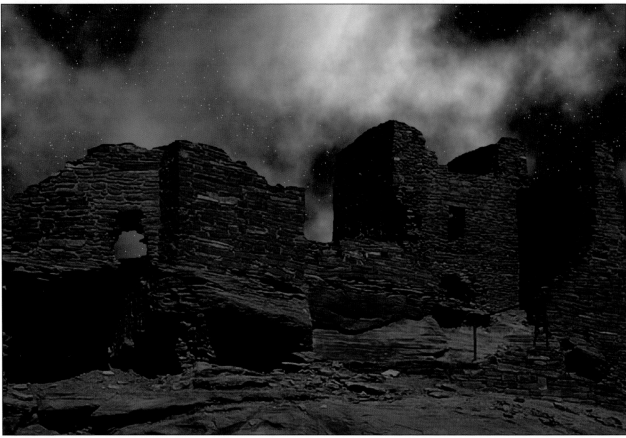

Final image.

But you don't even need to use a plug-in if all you want is a simple star field or even star trails. Make your own!

Start with a new image and fill the image with a dark color. This could be black or a deep-blue color, depending on the ultimate destination of this sky (we'll be pasting it into the background of our host image).

Use a white paintbrush (with a sharp edge, rather than soft edge) to paint on some stars. If you want to be more realistic, you could use a star chart or planisphere to help you draw real constellations. Vary the size of the stars slightly to simulate the variation in brightness. Also, use pink or pale blue for some stars.

A New Sky. Whether you've created your own or produced something novel thanks to Glitterato, it's easy to take the resulting starfield and replace an existing sky.

Use the selection tools to select the sky area. If you have a steady hand, you can use the Lasso tool. Or, use the Magic Wand tool to select the color of the sky. You may find that the Magic Wand doesn't select precisely in low-contrast situations like this, so you can add to the selection or use other selection tools to add or remove parts.

Select the Starfield image and copy it to the clipboard (Select>All, then Edit>Copy).

Return to the skyscape and select File>Paste Into. The sky will be pasted into the selection. You may find that you need to alter the size or position of the sky. Use the Transform command (Edit>Transform) to get a good fit.

You may also find that the result is better if you blend together the original and new skies. Use the opacity slider on the Layers palette to reduce the opacity of the new sky slightly. So there's our new sky. Can you see the join?

Anywhere Anytime Lightning. Okay, so we were a bit blasé when we talked about how frequent electrical storms are. True, there are many places in the world where you can virtually guarantee a good show two nights out of three, but if your last memory of a local storm could be measured in months or years rather than days, you need an alternative.

And that alternative comes thanks to a plug-in from Alien Skin Software's Xenofex collection. The filter imaginatively called "Lightning" produces a bolt of lightning on demand, bright enough to emblazon daytime shots as well as nighttime photos.

Like Glitterato, you have full control over the parameters of the lightning, the number of branches for example, and you can control the extent by restraining the effect to a selection within the image. But for good measure and to ensure that, like in the real world, no two results are ever the same there's a randomizing feature thrown in, too.

Alien Skin's Lightning filter produces lightning on demand.

3. The 24/7 City

*S*unset and landscape photography puts us at the mercy of the vagaries of the weather. There is nothing more demoralizing to the low-light photographer than that band of cloud that, after a long preparation despoils a magnificent sunset or shatters an ethereal dawn. Towns and cities, however, provide virtually assured results, no matter what the weather. And they provide us with a wide assortment of scenes. Nor do you need to be in a big city—even smaller towns and villages can provide ample opportunities for the sharp-eyed photographer.

As the sun goes down and the sky gets a darker blue (or a darker gray, if the weather proves less giving) the city seems to spring to life as lights appear in buildings and along streets, and floodlighting reveals classic daylight landscapes in, literally, a new light. Rainy weather? It may make working a touch less comfortable, but it doubles many of your photo opportunities as the rain-soaked streets reflect every light, sometimes twisting and distorting them into intriguing abstract forms.

One of the best things about night photography in the city is that you have more time on your hands.

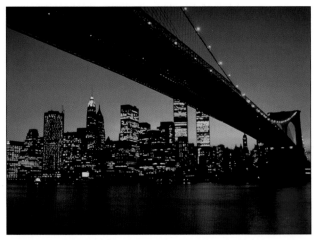

Cityscapes provide amazing dusk and night shots. But, just as landscape photographers often get their best shots by isolating an element in the scene, so some individual buildings can deliver impressive shots in isolation.

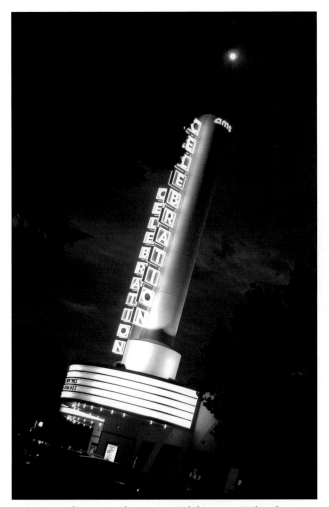
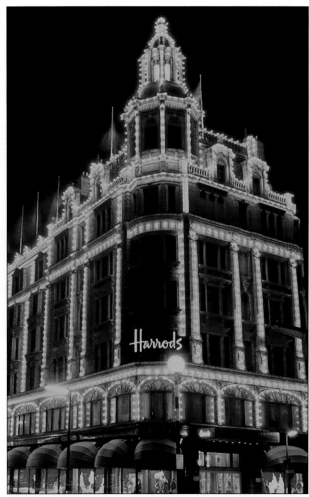

LEFT—Here the movie theatre at Celebration, FL, has been caught in the last moments of twilight. RIGHT—After dark, buildings that are impressive in daylight take on new life. The delicate architectural tracery of a department store has been picked out by standard tungsten light bulbs. In isolation, a single tungsten bulb is rarely photogenic but en masse, the effect is stunning.

Apart from that ephemeral twilight time when you can catch illuminated buildings set against vivid mauves and blues, you have plenty of time to consider your photography, then compose and recompose until you get a scene just right. You can also equip yourself with a bigger collection of equipment than you might otherwise.

City photography can be about capturing wide panoramas, or small details; multicolored facades or minimal interiors. You'll need a good wide-angle lens—a 24mm is good, 21mm is better still. These will be perfect for capturing great images in the vast canyons of downtown streets and also cramped interiors. With the virtue of a tripod you can also make use of versatile zoom lenses such as a 28mm–200mm or even a 28mm–300mm. These

become 40mm–300mm and 40mm–450mm when attached to most digital cameras and, though their maximum aperture tends to limit their low-light applications, here in the bright city they come into their own. Working with a tripod also means you can use slow ISO settings and get sharp, color-rich results with little in the way of noise.

◼ EXPLORING THE CITYSCAPE

Cityscapes provide a wide range of opportunities for the low-light and night photographer—though that wide range can sometimes seem as if it's been produced by opening a nocturnal Pandora's box.

On the positive side, you have scenes comprising spot-lit buildings, moonlit landscapes, neon lights, and other illuminations. But on the negative, all

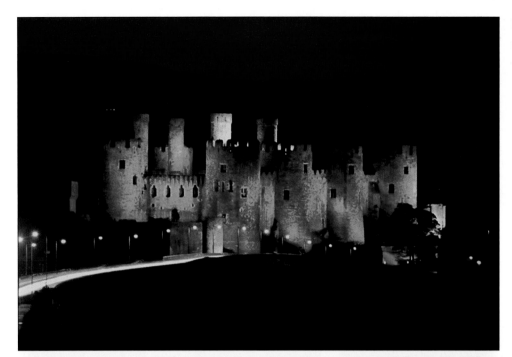

Floodlit, this Welsh castle completely dominates the night landscape.

Don't overlook the more surreal elements of city nights. When the rain comes, many people head inside or for home; the low-light photographer takes advantage of the new perspectives available.

these light sources that, to our eyes, appear to combine to produce such an exciting landscape, don't appear in such a synergistic way to the impartial and unemotive eye of the camera's CCD. So we need to be discriminating in how we approach the subject; we must concentrate on light sources that work together not only in compositional terms but also in illuminative ones.

The Highway. There's something of a cliché about the highway night scene. Every book and web

site on low-light photography includes at least one example. If the description so far doesn't strike a chord of familiarity, the images will.

Stand on a pedestrian bridge over a busy urban highway or freeway and mount your camera on a tripod (avoid clamping the camera on to the bridge itself to minimize vibrations). Set the camera to a long exposure and the aperture to around f/8. Now, shoot the traffic as it passes below. The result is a series of trails caused by the headlights and tail lights.

Look up, look down. Building interiors offer great photo-opportunities if only you explore all angles (here, a Chinese temple and a lighthouse).

Experiment with different lengths of exposure. Shorter exposures will show the motion of the vehicles rather in the manner of star trails, against a dark background. Longer exposures draw the cars' lights into more surreal lines that tend to define the shape of the highway. Longer exposures will also help define the roadway in the landscape. Over the course of a longer exposure, the compound effect of general and specific (highway) illumination will light the surroundings.

Neon Lights. Neon lights can be modest, a single light illuminating a store window perhaps, or fantastic, displays typified by those on show at Las Vegas- and Disneyland-type resorts. However extensive the displays, though, the approach needs to be the same.

You'll need to take a light reading that is not unduly influenced either by the dark surroundings or the brightest of the lights. As usual, using the camera's LCD screen is a great way to help "guesstimate" the right setting.

Pay attention, too, to the composition. Big lighting displays can capture imagination very easily and it is then all too easy to snap away without consideration for the composition. Crop tightly on the display and, where possible, add depth to the scene by including foreground elements.

Try This. Here are some guide exposures for city scenes. Use these as starting points for your own experiments. These values are based on an ISO setting of 100.

LOCATION	EXPOSURE
Bright floodlit civic building	$\frac{1}{2}$ second at f/2.8
Floodlit church	1 second at f/2.8
Light trails	10 second at f/8
City street scene (typical)	$\frac{1}{10}$ second at f/2.8
Brightly lit street (Christmas or carnival lighting)	$\frac{1}{15}$ second at f/2.8
Shop window	$\frac{1}{8}$ second at f/2.8
Brightly lit store fronts	$\frac{1}{15}$ second at f/2.8
Neon lit city buildings	$\frac{1}{30}$ second at f/2

CHEAT'S GUIDE: FULL AUTO

For this auto-everything shot of a floodlit building the results are overly bright. Using the Levels command, rather than Auto Levels, an accurate rendition is achieved.

All digital cameras offer an auto-everything option. That includes all cameras from the lowliest point-and-shoots right on through to professional-grade models. Sometimes you'll have only an automatic mode, where no manual intervention (save for deciding where to point the camera) is possible. Others, including the professional models, may not have a mode that is overtly marked as "full auto" but will offer a program mode that, coupled with factory-default settings, will be automatic in all but name (some professionals won't ever use automatic modes, others won't ever want to think they use auto, hence the more euphemistic names).

"Auto" means all the parameters and settings necessary to get a perfect shot will be set by the camera's central processor. This includes focusing, exposure, flash, and white balance.

If we left the camera to its own devices—or rather, if the camera was left to do anything and everything to get the exposure right—we'd end up with a low-light shot that would offer none of the mood of the actual scene. The camera would automatically expose to produce an image of average light and color values. Night and low-light shots, though, are not average; they are heavily underexposed. But most cameras—particularly simpler ones—don't have the range of adjustment to accommodate the delivery of correct exposure so the results end up overexposed! They may not be underexposed to the precise exposure value we demand but it will be close enough to allow a little darkroom manipulation.

Ironically, it is the better specified cameras that will fare worst in this auto-every-thing scenario. They do have the range of adjustment that can handle low light levels and will compensate accordingly. Dial in an exposure compensation of −2 stops (using the exposure compensation control) and you'll find automatic results fare much better. And you can fine tune this compensation until you get the best results!

So…are there any other red flags to be aware of for total auto? Just a couple. Depending again on the sophistication of the camera, you may find that there is a limiting light level below which the autofocus system won't work. And the LCD panel that you've come to trust for framing and previewing may not be the stalwart friend you've come to trust. Low light makes it harder to view and the final exposure will often differ dramatically from that show beforehand.

Oh, and automatic flash. A burst of automatic flash is often obligatory with simple cameras at low light levels and there isn't much you can do about it. On other models make sure the flash mode is set to "no flash."

Automatic controls come into their own in mixed lighting environments. Here, in the Saturn V Hall at the Kennedy Space Center, there's a mix of tungsten, fluorescent, halogen, and low voltage GA illumination. Left to its own devices, a simple digital camera delivers ideal results.

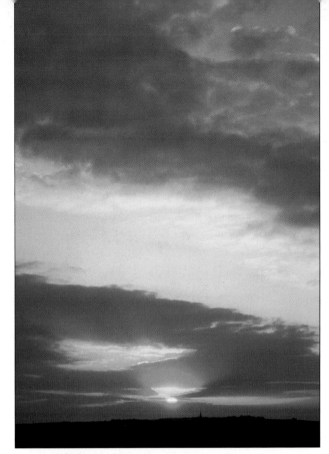
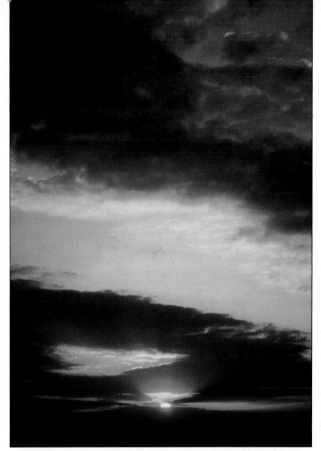

Combining this image with a copy of itself and changing the blend mode to Multiply gives a deeper and more colorful result.

■ ENHANCING NIGHT SHOTS USING BLEND MODES

They seem to crop up in menus and dialog boxes throughout Photoshop and many other image editing applications, yet many Layer Blend Modes are rarely used to their full potential—if at all. This is often because their action can seem mysterious and unpredictable. But with just a little insight into how they work you'll soon be able to exploit some of these to enhance and empower some night shots.

Layers are fundamental to the creation of image montages and composites. They allow us to combine elements drawn from more than one image. This emulates some of the montage techniques used in the traditional darkroom. Here, we might expose part of photographic paper to one source image and part to another to create a new artwork. Alternatively we might combine two transparent originals (negatives or transparencies) in the same mount and produce a new image from this visual "sandwich."

In fact, layer blend modes allow us to combine images and image elements in many ways, each with a distinct effect. When we apply a blend mode, the pixels of a layer are combined with the corresponding ones of the background. It is the way that this combination is enacted that determines the effect of the blend mode. In blend-mode parlance we describe the lower image as the base layer and the overlaid one as the paint layer.

We're not here to explore every one of the blend modes on offer—the list is extensive and seems to grow even more so with each revision of Photoshop. We'll sideline some because the differences between them are slight. Others are rather specialized in their application. We'll concentrate on those that are most useful to our low-light and nighttime work.

Normal. The default blend mode is Normal. When set to Normal, an opaque layer (paint layer) will completely obscure the base layer. When the opacity of the paint layer is altered (using the Opacity slider on the Layers palette) it becomes less dense and allows the background to partially show through.

Multiply. When we want to combine two images in visually the same manner as if we'd combined two transparencies in the same slide mount and rephoto-

This image has been combined with two copies of itself, with each copy added as a new layer. By changing the blend modes to lighten in each case we get a more even illumination and more of the dimly lit detail is revealed.

graphed the result, we use Multiply. An image comprising two layers combined in this way is always is always more dense than either of the originals. When we combine two identical layers we build density and contrast. It's an ideal way of dealing with overexposure, or partial overexposure. If part of an image is too light, its density can be increased by combining it with a multiplied version of itself.

Screen and Lighten. Imagine a similar process, but this time we sandwich two negatives together and print the result. The result would be lighter than a print created directly from either original. This is the effect of the Screen and Lighten blend modes. They combine the base layer with the inverse, in luminance terms, of the paint layer. If you get a feeling of déjà vu here, don't worry. Exploiting this blend mode was one of the techniques we used earlier to help place the moon convincingly into a new scene. The difference, as you'll see if you experiment with these blend modes yourself, is that you tend to get a more luminous glow with Screen mode, while

Lighten produces a softer result. Lighten works better when you want a subtle addition (in the case of the moon, when you want the moon not to dominate the landscape).

Overlay, Soft Light, and Hard Light. Also of interest, though perhaps less so than Screen or Multiply, is this trio. They can be considered together as they produce results that vary only in the amount of their effect. In each case, the resulting image has the same appearance as we would achieve if we printed the base layer image on photographic paper first and then exposed for the paint layer. Soft light gives the most gentle effect, whereas hard light gives a more pronounced effect (with the paint layer more obvious). Overlay gives an intermediate effect.

Look through the blend modes and you'll see there are many to explore. Our advice would be not to spend too long working out the subtle differences. Just learn how to use a key few, including the ones we've discussed here. You'll then quickly pick up or discover opportunities to use more.

◼ STAINED GLASS

Stained glass has been used for centuries to illuminate the interior of grand buildings. This has included homes and civic buildings, but most often it has been churches and places of worship. They were originally designed to allow light into the interior of buildings while preserving the sanctity of that interior by modulating the light in color and strength.

Lighting. When we photograph stained glass, we need to be mindful that, unlike most photographic subjects, which shine from light reflected off them, the stained glass is seen by virtue of the light transmitted *through* it. In this respect, the window is like a large transparency on a lightbox and we need to expose accordingly.

Because stained glass is generally illuminated by the daylight outside the building, the appearance of the windows will change according to the outside weather conditions, time of day, and even time of year. Every permutation of these factors will bring about different shooting conditions and present a different aspect to the view.

When you have a specific window to photograph, you'll need to do a reconnaissance mission to determine the best time to photograph. In terms of color,

a window will look its best with the sun immediately behind it. Color saturation will be at its best and there will be a sparkle to the light.

This doesn't, however, necessarily make for the best picture. If the sun is right behind the glass, it will produce a hotspot and uneven illumination. Light clouds will be better and will act rather like the frosted glass we use on the top of lightboxes.

There are two other factors to consider when photographing glass. The position and the setting.

Position. Stained glass, in churches at least, tends to be placed high up. Unless we are blessed with the opportunity to be able to climb high in the church, this will mean pointing our camera upward to successfully include all the window. In doing this our images will suffer from converging verticals; rather than a rectilinear image of the window, we'll get one where the top of the window appears distinctly narrower than the base.

Unfortunately, this effect will occur even if the church boasts a long nave and we can stand at the back. Our options are either to make a virtue of this (even exaggerating the amount of convergence) to emphasize the height and scale, or to remedy the problem using our image-manipulation software.

Not all stained glass is found in buildings. This huge pane is slung between trees in an British sculpture park. Though impressive throughout the day, at certain times the backlighting leads to a spectacular burst of color.

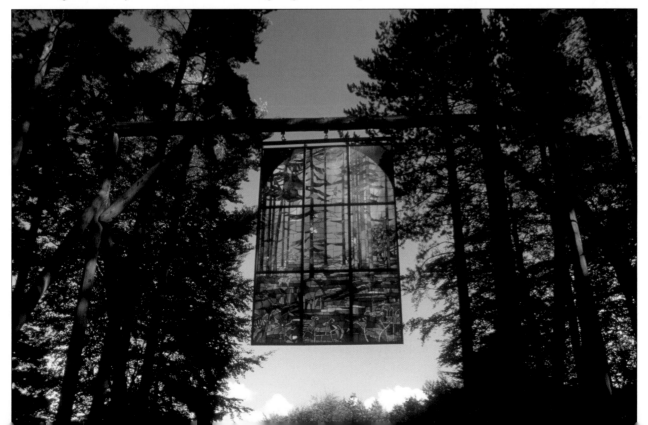

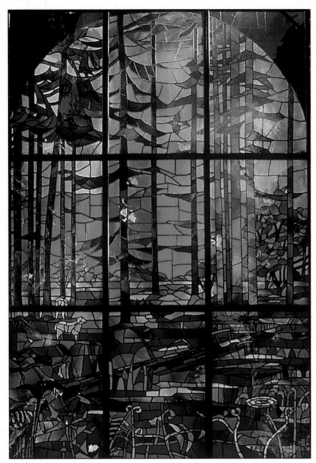 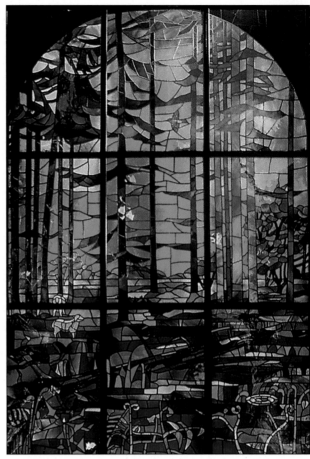

LEFT—It's possible to make a feature of the window (see previous page) using the Crop in Perspective feature (see page 61). We can then isolate the window alone, correcting the convergency. RIGHT—Next, we can increase the contrast and use a modest amount of sharpening to make up for the softness introduced by the cropping and resizing.

We'll take a look at this momentarily.

Setting. Often we can achieve a more powerful image by photographing the window in its setting, including parts of the church or other building that contains the window. This makes the exposure slightly more problematic as there can be a quite substantial difference in brightness between the window and the building interior.

The best way to even out this difference is to use a flash unit—and this time, the bigger the better. We will need to set our camera to expose for the window and then set the same exposure settings on the flash. Most interiors will be too large to successfully illuminate using bounce flash techniques, so use direct flash, perhaps fitting a diffuser over the flash itself to reduce the possibility of a hot spot occurring. Now, you'll probably be thinking of all that sober advice that says never use flash when you are photograph-

ing at or through glass. This is very good advice, but this really is the exception that proves that rule. Unless you are lucky enough to have found a shooting position that places you squarely in front of the window your camera's angle to the glass will mean that there won't be any reflections from the glass itself. And the amount of scattered flashlight returned from the window will be negligible compared to the light coming through the window.

Shooting the Glass. A tripod or support may not be necessary for shooting windows, because the backlighting may be strong enough to allow hand holding—but it's still a good idea. It will give you the opportunity to compose your shot well and check the alignment. Try to align yourself perpendicularly with the window. This will prevent additional distortions (in addition to any converging verticals) produced by a skewed shooting position.

CORRECTING CONVERGING VERTICALS

Straightening up the converging verticals in our stained glass photography is a simple task—and we can use the same tools to correct similar perspective effects when we photograph buildings.

This window view (image 1) might be typical of many we might take. The low viewpoint is great for inferring a sense of scale but is inappropriate where accurate portrayal of the window is required.

Corrections are made with the Crop tool (image 2). When we select this tool from the tool bar we need to ensure that we check the box in the options bar (below the menu bar) marked Crop in Perspective. Now drag across the selection from the top left to the bottom right to make a selection. You'll need to include as much of the image as possible.

Look carefully and you'll see that there are small boxes at each of the corners of the selection (image 3). We call these handles because when you click on them and hold down the mouse button you can drag the corresponding corner of the selection.

Use these handles to adjust the sides of the selection so that they match up (that is, run parallel) with obvious verticals in the image. The edges of the window are an

obvious choice here (image 4(. If you were not squarely in front of the window, the amount of adjustment on each side may be slightly different. You can also adjust, if appropriate, any horizontal lines at the top or bottom of the image.

Now press the button on the options bar marked with a check mark to apply the crop (image 5). The image will be resized, with

Image 1

Image 2

Image 3

Image 4

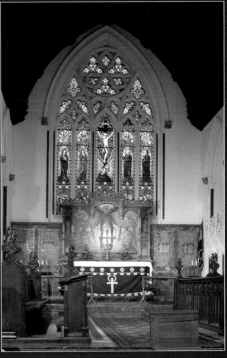

Image 5

the area outside the crop lines being discarded and the remaining image adjusted to fill a rectangular frame.

If you have an earlier version of Photoshop that does not include the Crop in Perspective command or are using an application that does not have the feature at all, you can get a similar—if not identical—result by using the Transform commands. This allows us to distort the image in the same way as perspective cropping

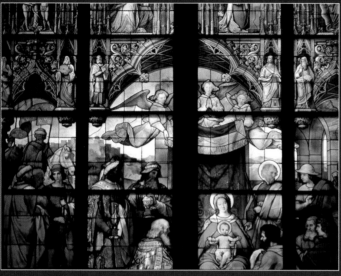

Image 6

Don't ask me why (because it just seems to happen!) but sometimes when you apply a Crop in Perspective the final image seems unusually stretched in the direction of the original convergence. Set this right by selecting Image>Image Size to open the Image Size dialog. Uncheck the box marked Constrain Proportions and alter the height of the image. Adjust in 5- or 10-percent increments until you get a result that looks right.

Another problem with some stained glass windows is that their scale dictates strong supports between panes. These have no impact to the visual appearance in situ but can compromise photographs. Here is a good case. This window is divided into panes with substantial structural supports (image 6).

We can narrow these by copying and pasting sections of the window and dragging the pasted sections to reduce the pillar thicknesses. This process required that we first corrected the slight case of converging verticals in the scene. For the final image we have also copied the whole image into a new layer and changed the blend mode to multiply (image 7). This gives the net result of intensifying the colors within the scene. You need to take care not to narrow the pillars too much: the scenes in the window take account of the pillars in their geometry. Cut the pillar width too much and there will be an obvious discontinuity in the image.

Image 7

LEFT—At night, two enormous sets of floodlights project searchlights across the Paris. Although bright, their motion makes them barely visible; they are certainly outshone by the floodlighting of the Eiffel Tower itself. RIGHT—To recreate the effect, spotlight shapes were drawn using the Lasso, feathered 10 pixels. The selections were extended so that when the white paint was applied we could make the beams appear to fade away from the tower, as they would in the case of an actual beam.

Take a meter reading off the window itself. You may need to zoom in to take this measurement to ensure that none of the surrounding building or tracery contributes to the meter reading. If your camera has an exposure-lock button, press this when you have taken the reading and reset the lens to the chosen focal length. Now you can also set your flash unit if you want to include the building interior.

Shoot away. Check your results on the LCD panel. You may need to alter the exposure, generally by reducing the exposure time or aperture, to get more saturated results. The balance of any flash lighting and exposure may also need to be adjusted for best results.

If you find strong sunlight illuminating a window, you can often get some great images of the building interior lit by the colored glass. You'll definitely need a tripod for this one, as the reflected light will be well attenuated, but the play of color and form can produce some intriguing shots.

A Final Point. Because some of the finest stained glass is found in places of worship, please be mindful and respectful of that place. In all cases, it is courte-ous to ask permission to photograph first. Some places will have restrictions, whether for religious or practical reasons. Some may have restrictions with regard to the time—for instance, you may be able to shoot only when organized worship is not planned.

I find that when asking permission, you are very rarely refused—and I have also found that it can pay dividends. When you show your serious intent, not only will you be more warmly received than a casual visitor, you may also be able to gain access to areas (and photographic angles) that you might otherwise not.

■ FLOODLIGHTING AND SPOTLIGHTING

In the nighttime cityscape, the most impressive of buildings are those illuminated by floodlighting. However, floodlighting provides a dilemma. If you expose for the floodlit building the less strongly lit surroundings will prove too dark to register. Expose to allow these darker areas to record and the subtle-ty of the floodlighting detail will be lost.

Cue the darkroom magic. When the light levels of floodlit areas and the surroundings are too disparate

to be accommodated on the same shot, we can combine an evening view and night shot in the same image. You can paste the night shot over the original image as a new layer and adjust the transparency to get the best overall effect.

But where we need to give a true spot-lit effect, we need to be a little more artistic. With a little sleight of hand we can even highlight subjects that perhaps are not adequately illuminated—introducing our own floodlighting.

The now-dismantled Body Zone at London's Millennium Dome was a massive structure that, at night, was illuminated by a large number of spotlights. Though not detrimental to the sense of scale, the lighting is rather lackluster.

After boosting the color saturation and the contrast slightly, the Polygonal Lasso was used to define large triangular shapes from each of the floodlights. With the selection feathered and using the Brush tool (with the opacity set to 5 percent) the selection was infilled to give the beam effect. Then the Burn tool was applied to the point where the beam hits the subject to enhance the illumination effect.

4. Special Events

*I*f you think about it, there are quite a number of special events that take place at low light levels and in this way—and others—make it difficult to successfully record exciting, photographically acceptable images.

Christmas, for example. Not only does it (like similar festivals in other religions) take place when the sun makes only the most cursory of appearances for those of us in the northern climes, but most of the most memorable events (from the photographic point of view) tend to happen either indoors or after dark. Think of illuminated streets, parties, and evenings by the log fire. None of them could be considered to be anything other than dimly lit.

But for the low-light enthusiast, there is much more to photograph by way of special events. Sporting fixtures provide varied opportunities, from the regimented arena- and stadium-based events through to street-racing and open-country events. No matter what your sporting interest, you'll find something to challenge your new-found skills.

Not a sports fan? Then how about the theatre, or even concerts? More opportunities and chances to explore creative photography at the edge. Through this chapter, we'll explore each of these and more, discovering not only the photographic techniques

Christmas is a great time to take your camera out at night. Unexpected opportunities can present themselves such as here, where a forest takes on a magical appearance when illuminated by colored lights.

ABOVE—A choir of angels? Carol concerts and singing events are, like drama presentations, easy to photograph and a few little tricks will ensure that you get great results even in the most difficult of conditions. LEFT—Foreign travel brings even more opportunities, such as this Thai performer.

The fairground makes a great hunting ground for images. You'll need to brace yourself against a convenient support, as here, and correct the image after. The manipulated image here has had converging verticals corrected, superfluous areas removed, and been sharpened (to compensate for the softness of the lens at full aperture).

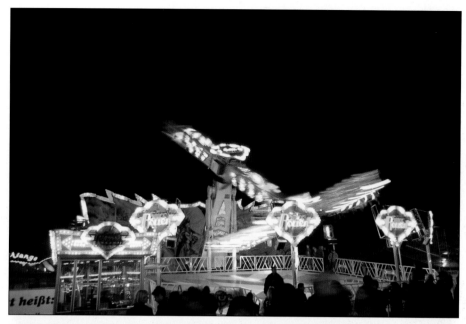

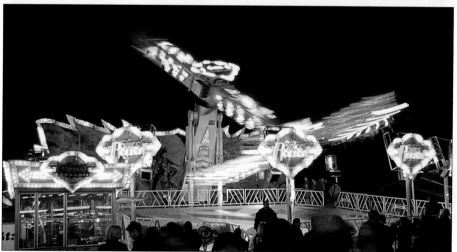

that need to be exploited but also practical skills that will help you to get the best positions and best prospects.

■ SPORTS PHOTOGRAPHY

Sports photography may not be our first thought when considering low-light conditions, but a surprising number of sporting activities are enjoyed—if that is the right term—under the most adverse of conditions. Sports photographers are considered, even by their photographic peers, as a breed apart. Working under difficult circumstances and the most desperate of deadlines, they need to work fast and would be the first to admit that luck plays a not-inconsiderable role in their success. Unlike many low-light subjects,

sports photography requires capturing moments in time and, as such, demands a somewhat different technique.

Freezing the Action. Sporting event often run for several hours. Some games, such as cricket, can even run for days. So it's somewhat ironic that sports photography is concerned with capturing instants; instants when a decisive shot is played, when an expression of extreme emotion is displayed, or a critical moment in the play occurs.

To freeze action, it's no surprise that we need to use the light from a flash. That burst of light delivered from a flash can be as brief as $\frac{1}{50,000}$ second which is an order of magnitude faster than any shutter speed offered by conventional cameras. Unfortun-

Soccer was traditionally a winter sport; mud and dark skies were de rigeur. It's often details that say more about the game than outright actions. In this junior-league game, I used the goalkeeper to direct the eye to the action.

ing a longer exposure—such as ⅟₁₅ second or ⅛ second can enhance the amount of the scene recorded by ambient lighting. This length of exposure will also record some motion on the part of the participant before and after the flash burst.

With some judicious use of the flash you can apply a more subtle lighting: fill-in flash. This mode, which can be set to apply automatically on most cameras or flash units, balances the ambient light with the flash to produce more even illumination.

The Decisive Moment. Whatever the lighting available, ambient or flash, the key to getting a shot that looks great is choosing when to press the shutter. Of course, this is true for any subject that involves movement, but is particularly so in sports photography. Take a shot just a moment before or after what we term "the decisive moment" and the results just won't make the grade.

Hitting the decisive moment on the nose requires two things. First, you need to know your sport inside and out so that you can accurately predict when that moment will occur. Second, you need to know your camera. With conventional SLR cameras, there is always a very slight lag between pressing the shutter and the film being exposed. It's a tiny lag, but one most of us have come to accept and predict. Digital cameras tend to have longer lags. Continual improvements in design have shortened this lag from the intolerably long ones that characterized early models, but, in general, the lag on a digital camera is longer than conventional.

Predicting the action is the only way to get a shot spot on—but you need to be prepared for many failures (in timing terms) along the way.

Some cameras include a cute feature that can almost guarantee getting shots spot on. They record shots—often as fast as four per second for as long as the shutter remains open. But only four (or sometimes six) images are retained at any one time; as soon as another shot is recorded, the oldest of the sequence is discarded. By using this mode and taking your finger from the shutter release at the decisive moment, the shots leading up to and (hopefully) including it are all stored.

ately, many of our key sporting venues—and sports—make it logistically impossible to exploit this brief burst of light, but that does not preclude its use in other sporting situations.

Flash photography works best with sports such as cycle racing, cross country and rallying, where it's possible to get modestly close to the action. The best time to shoot is when the light is failing rather than after dark. On these occasions, the flash will freeze the competitor, but the remaining exposure will record more of the surroundings. Deliberately select-

Most digital cameras have underwater housings that allow the camera to be used in the pool or the open sea. Just below the surface, the color balance can change dramatically, but this is more than made up for by the subject.

Curling event are often held indoors where lighting can be problematic. To make the best of this shot, the white balance was set to auto.

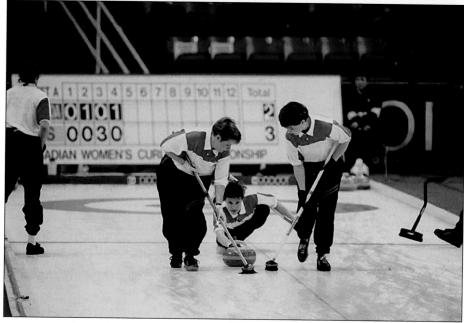

Indoor Arenas. If you are determined enough, there's no sporting event that will defeat you. For cutting your teeth in this arena—and no pun is intended—indoor team sports provide the best introduction. Volleyball and basketball courts, whether at the local high school or an international venue, are sufficiently compact to make getting great shots comparatively simple. The benefit of local venues is that access is comparatively less restricted and you'll find the use of cameras is less proscribed. The compact nature of the arena also means that you can

use short lenses, including 50mm prime lenses. Performing as 80mm portrait length lenses when used on digital SLRs, these are available in wide apertures (such as $f/1.8$, $f/1.4$, or even $f/1.2$) at reasonable prices, letting you hand hold and get sharp shots using the ambient lighting.

Enhancing Sports Shots. Enhancements to sports shots are many and varied. Perhaps the two most significant (and certainly the most widely used) are the zoom blur and enhanced depth of field.

The zoom blur is an effect that can be achieved in

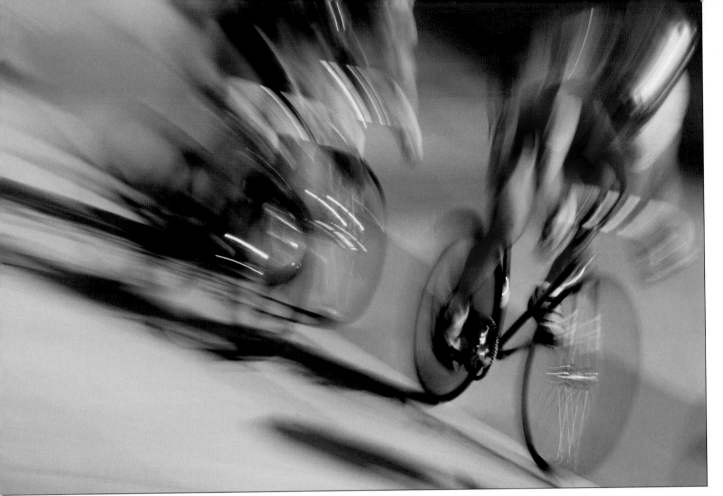

Okay, so this is not a low-light situation, but shows well that blurring can add impact if used creatively.

camera. It requires that you select a modestly long shutter speed— ⅛ second or slower—and, during the exposure, rapidly adjust the zoom ring on the lens. When done well, this can be very successful. However, it requires not only that you hit the action at the decisive moment but operate the zoom without otherwise shaking the camera or losing the focus. Many zoom lenses—particularly power zooms on compacts won't even allow you to operate the zoom during and exposure.

Helpfully, and thankfully, Photoshop allows us to apply a zoom blur to any shot we choose. You'll find the option in the Blur filter set, under Radial Blur. Click on the Zoom button and move the zoom center point to the center of the action in the shot. Then apply. You can vary the amount of zooming from a modest setting through to the most dramatic one.

Enhancing depth of field helps separate the subject from background and foreground distractions. You'll get a result rather similar to using a wide aperture on a telephoto lens.

In the digital world we achieve this effect by selecting the subject—and anything else at the same distance from the camera—and blurring everything else slightly (by inverting the selection and applying a Gaussian Blur filter). For a more realistic effect, you can select parts of the scene that are progressively further (in front and behind) the camera and then blur these progressively more.

◼ PHOTOGRAPHING THEATER AND SHOWS

It was said of master photographer Max Waldman that he did not go to a theatre to photograph a performance, he would instead invite the production to his studio. Few if any of us have the ability to do likewise and work in a controlled, studio environment. No, we must learn how to exploit theatrical settings and lighting.

Theater is, by nature, a rather flamboyant medium and is full of photographic opportunities. Whether a school play, Broadway show, or high opera, it's a gift for the photographer.

Copyright and Access. Photographing theater can raise issues associated with copyright and access. Copyright laws sometimes limit photography. You'll find that for virtually every commercial presentation there is a total ban on video photography. This can sometimes be extended to still photography as well. Sometimes a blanket ban is imposed by the theater simply because it is easy to enforce: no cameras, still or movie. Other places are more amenable. If you are attending a performance for the purpose of photographing it, contact the theater first and let them know of your intentions. Make it clear how you will be photographing (in particular, let the theater know that you'll be using available light—flash is a no-no). Bans on photography are often imposed because of the annoyance due to flashes firing. If the theater then says no, you'll have to accept their decision.

Of course, you could gain favor (and possibly freer access) to *any* theatrical performance—big budget or high school—if you are able to show some shots from your portfolio and even offer to make the photos you take available to the cast and management free of charge or, at least, at cost.

Approaching an Event. Assuming photography is permitted how you approach photographing the performance will depend on the nature of that performance. A great grounding in theater photography is to undertake the production photography at your children's school productions. Here, you will find your serious intentions will probably be gladly accepted by the school (in exchange for a copy of the best photos) and you'll probably have VIP access. The same goes for amateur dramatic productions. The stars of such a show will probably be more than accommodating (thank God for egos!) of any requests—and you may get to see the show for free, too!

For that Broadway show, you'll need to be a little more circumspect and—unless you are extremely lucky indeed—accept a fixed vantage point. If you can (and if you're visiting the show with family or friends) a box is ideal. It gives you more room to spread out and the noise and commotion of changing lenses, memory cards, etc., will be less of a prob-

lem. You may also get some better angles on the stage.

Preparations. If you have the opportunity, get to know some of the key people involved in the production. This is particularly important if you are being given special access. You need to know where, and more importantly where *not*, to go during the performance. It will also help if you get a chance to preview the performance before attending with your camera. This will give you the opportunity to make notes of some "must-have" shots and angles.

When to Shoot. Any performance, from a play at an elementary school through the grandest of operas, will have at least one dress rehearsal and often a technical rehearsal, when all lighting and

Freezing movement at low light levels is often difficult, if not impossible. This gives us two options. The first is to shoot only when there is little or no motion. For this junior ballet performance of Cinderella, the ballroom dancers have been recorded in a final pose and doing an encore.

The other option for fast-moving subjects is to make the motion obvious to an almost absurd degree. With long exposures, there is little sharp detail but this conveys the flowing motion of the dancer.

props are put through their paces. These are great times to take photos. Unlike a real performance, there will be many breaks and interruptions and, often, scenes are held while lighting is adjusted. You may not have the spontaneity, but the time to compose and recompose will make up for this. Of course, even if you do have special access, it's important not to interrupt the show yourself in any way—the dress rehearsal is for the benefit of the cast and crew, not the photographer. But that's not to say some obliging companies won't mind spending a little time at the end (assuming the rehearsals were not too onerous) staging some scenes for the camera.

It's a good idea to have a dress rehearsal yourself. Use it to make sure you can make all the necessary adjustments to your camera in the dark and easily find alternate lenses—all without disturbing those around you. It's a good idea, too, to set your camera to silent mode. It's surprising how far the sound from those little focus and save beeps travels and how annoying they will become to your neighbors. When you hear an announcement saying "Please turn off your cell phones!" remember to check your camera's audio features too!

Theater Lighting. We've already said that flash in the theater is an absolute no-no. Rarely will a flash unit have the range and power to be of any use, and the distraction is unacceptable. This applies to school performances, too, though we have to excuse parents' jumping up and down with their auto-everything cameras. The good news is that theater lighting (and here I'm grouping together all types of theater, from the school gym through to the grandest of opera houses) is generally good enough to allow action-freezing photography.

But this light can be variable. It's all about creating mood and illusion, so you may find the lighting changes from second to second (another reason to be familiar with the production). Your camera's meter will take most changes into account, but you may have to dial in an exposure compensation at appropriate points to preserve the atmosphere of dark or bright scenes.

Stage lighting as also rather harsh, producing strong highlights and black shadows. Don't expose with the expectation of recording shadow detail because, most often, there isn't any. Theater is a make-believe world and the lighting is unlike that elsewhere! Worse still, you can expose for the midtones and find the highlights blown away.

Composition. Composition is important in any photograph. In the theater we are, to greater degree committed to compositions that have been created by the writer and director. But their aim, too, is to create the best visuals for the production. Capitalize on this when you shoot. Look for obvious scenes when key characters are close together and gesturing; these scenes always make for good images. And reserve wide-angle shots of large parts of the stage

for the chorus line or curtain call. Otherwise, like shooting an impressive landscape with a wide-angle lens, you'll find all the key elements of the scene so reduced in size that the photo will lose much of its impact.

Adding to the Drama. Don't forget that there's more to theater than the performance. The building,

if it's a purpose-built theater, can often provide some great photo opportunities. Some of the behind-the-scenes activities can also contribute great images.

Theater is a unique environment and puts special conditions on our photography. Here are some more hints and tips to help you get the best photos and to ensure no one is inconvenienced by your actions:

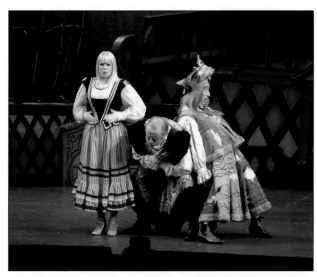

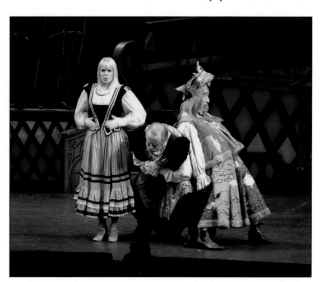

Theater lighting can be problematic. Here, there was a strong blue cast (to suggest nighttime) that does not reproduce as such photographically. The color balance controls were used to give a more neutral balance.

Bright lights and spot beams are characteristics of theatrical lighting, but often you'll find more subtle lighting can deliver more powerful results. Here a flautist, illuminated only by the pale lighting in the orchestra pit, makes a charming study shot. Similarly, a dimly lit Aztec figure is potent because of the equally dim lighting.

- Switch off or disable autofocus-assist lights. Many cameras fire these off in low-light conditions and they are remarkably bright—not so bright as a burst of flash light, but distracting all the same

- Use a lens hood. In a theater? Yes, there's a lot of stray light around that can impinge on the front of your lens. Maybe it's not essential, but it could just give some of your shots the edge.

- Watch for heads. If you are constrained as to where you can sit, it's almost inevitable that you'll get some heads in front of you. You'll either have to accept them as contributing to the atmosphere or zoom in to crop them out (either in-camera, or later).

■ CONCERTS AND LIVE ACTS

The demarcation line between theater and performances and concerts is a fine one. But concerts—by which we mean the rock-type—do need special consideration as, although much of what we have discussed with regard to the theater in general still applies, there are some further issues. Think about a typical concert. You will need to concentrate more on individuals, individuals who will, for the most part be moving rapidly and erratically about the stage. Lighting technicians will be blasting the same performer or performers with thousands of watts of lighting that often appears to change in color and intensity by the second. And you'll be restricted in access, position, and use of flash. Given these constraints, you'll begin to understand why there are relatively few good concert photographers. But that doesn't mean that you can't have a go yourself, nor that you can't return at the end of the evening with a great set of photos.

Gaining Access. It's unfortunate, but many bands and/or the venues at which they perform, restrict (and that means generally ban) the use of cameras. Sometimes it's for technical reasons, other times it's for marketing ones. Marketing? Yes, they want you to buy the official merchandise rather than create your own! Even at those venues where cameras are allowed, turn up with your beefy looking digital SLR and a couple of lenses and you'll find yourself treated as an unofficial pro. Even with a fully paid ticket and protestations of the highest degree, you'll be asked to leave the cameras outside or leave yourself.

So how do you gain access to such events? You'll need a press pass. And how do you get a press pass? By having a track record in the business. Yes, it's a catch-22. For your big break, you'll need to get an assignment from a local paper or magazine that holds enough sway to allow you to qualify for a press pass.

You'll have gathered by now that this is not something that you can just dabble with. You will have to show commitment and perseverance. Before a newspaper will commission you, they are going to ask for some evidence of your capabilities and invariably this is going to comprise a portfolio of past work. But before we begin to get into that uncomfortable catch-22 again, this needn't be gathered from simi-

A simple compact digital camera, with a zoom lens set to approximately 100mm (35mm equivalent) was sufficient for this shot of a soloist at Disney's Magical Kingdom. No special exposure was necessary.

RESCUE TEAM

Judicious cropping helps remove blurred elements.

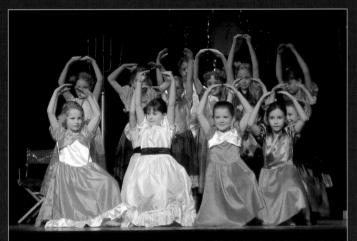

Applying a soft focus technique (right), as described on the next page, can help hide problems in the original image (left).

Compromise is one of those apologetic words that describes a situation that we know we could have bettered but, for one reason or another, didn't. In low-light photography it's a term that can crop up with unerring regularity. It describes those times when we had to use a shutter speed that was not quite as short as we would have liked; those occasions when we were caught out without a suitable support or, more often, when there was just not quite enough light to produce the precise result we expected.

Back in the bad old days, when remedial action in the darkroom was somewhat limited we had to resign ourselves to shots that were slightly below par. Fortunately, in that now-bygone world, the expectation of our marketplace (those who viewed our images) was also low. Now, when imagery has become more pervasive and sophisticated, those expectations are much higher. But now we have some tricks that can contrive to make those adequate images into something special.

The images above provide a good example. For this performance of *Cinderella* by an amateur ballet group, the high-school venue was not lit to professional standards. Light levels were lower than ideal for photography. Worse still, professional cameras were not permitted (thanks to some odd local ordinance). The only choice was to use a compact digital camera that had a top speed of only ISO 400 equivalent.

Consequently, many of the exposures were made at $\frac{1}{4}$ second at the camera's widest aperture, which is not ideal as the result can be rather soft images. So can we successfully record such an event? Sure we can. We just need to be mindful of the limitations. Here's some suggestions to exploit these conditions

DON'T SHOOT THE ACTION. With the exposure settings we're restricted to, it would clearly be impossible to freeze any action and, with a limited zoom ratio, impossible to capture tight close-ups. Instead seek out those parts of the performance that don't

involve much in the way of motion. There are plenty of opportunities to record momentary still scenes.

CROP. Judicious cropping helps remove blurred elements. In the images shown here (previous page, top), one of the performers at the curtain call makes a brief call to a fellow performer but this, unfortunately, produces a rather distracting element for the scene. Cutting away this part of the line may not make you popular with the parents of the cropped children but delivers a much more effective shot.

SOFT FOCUS. Soft focus effects can hide that proverbial "multitude of sins"—and this is no exception (previous page, bottom). Where we've taken shots that lack critical sharpness but are still sharp, we can apply the effect to conceal—to all intents and purposes—that lack. Copy the image into a new layer (Layer>

Duplicate Layer) and then apply Filter>Blur>Gaussian Blur, with a setting of 5 pixels. Finally, in the Layers palette, reduce the opacity of the new layer to around 50 percent. The subtle soft focus, combined with the sharp original gives a romantic look that deflects our attention from that lack of criticality in the focus.

IGNORE THE RULES. Sometimes you can't do anything to catch the performers sharply—so don't bother. In the image below, the dancers at the Prince's Ball were in full flight and our ¼ second exposure seems painfully long. But with a little cropping we get an ethereal shot that—while not revealing any detail in the scene—is excellent at conveying the light, airy movement. You wouldn't want too many shots like this, but the odd one makes a great counterpart to the more static shots.

Highly blurred action can sometimes create an interesting image.

lar events to that which you intend to cover. It needs to show your technical prowess; so it could comprise some (easier to get) theatrical work and some concert work that might have been produced of more modest stars and more modest venues.

Be up-front with any publication; give an honest appraisal of your skills and history to date, but don't undersell yourself either. If you are serious in your intentions, let them know—and keep telling them so! Don't be deterred if you don't get an assignment straight away. You may find yourself put on a list of possibles; bear in mind that most newspapers and magazines have staff writers who must earn their salaries and freelancers whose work is of a known quality and standard—and equally who know what the publication wants.

Spend some time at the small venues. Treat them like the theatrical venues, getting to know the staff there, and even offer some free work in exchange for access. Build a reputation with some unknown names and you stand in good stead to be asked in when some bigger ones appear. Your first step on the ladder!

Your First Big Event. Perseverance will pay off; keep telling yourself that and, when your work reaches that magic level, you'll find opportunities will present themselves. Then the hard work really begins.

For a start, you'll need to get used to the constraining regimes that apply at concerts. You've got your press pass and think you've unlimited access? No way. The areas you can work may be very restricted indeed. You may even find that having a press pass only allows you a limited time at the venue—you won't even get to enjoy the whole show. If you are asked to leave, do so with no protest. A well-behaved photographer is immediately differentiated from the paparazzi and is more likely to be recommended in the future.

It's quite normal for photographers only to be allowed to take shots during the early performances, perhaps the first three tracks. Some acts' managers can be more draconian and allow only a couple of minutes! This is not to prevent you from getting the

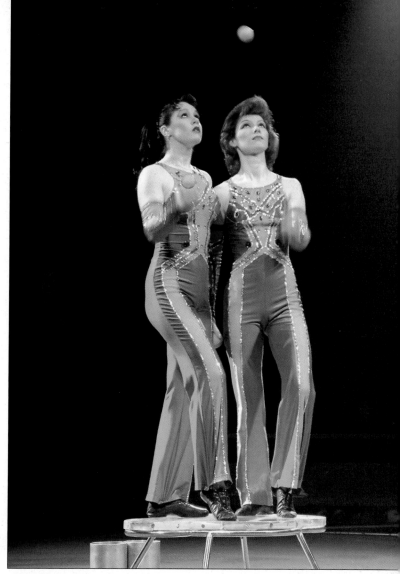

The dark background could have resulted in overexposure of these performers of the Moscow State Circus, but spot metering ensured that not only was the exposure correct but that a suitably short exposure resulted.

best shots, but out of deference to the tens of thousands of paying guests. Having paid good money to attend they don't want their view compromised by photographers who have the benefit of pole position for the time that they are there.

Travel Light. Once you've gained access you don't need to look the part. Forget those great kit bags packed with what seems like the complete inventory list of the manufacturer. Travel with the minimum. A good camera body is essential. For both credibility and practicality, this needs to be an SLR (though not necessarily a digital one—you could use a conventional one loaded with fast film and digitize the results later). Spot metering is almost essential.

You'll need this to cope with the small illuminated areas and the rapidly varying lighting conditions.

Lenses? Take a fast lens, f/2 or better, with 28mm and 50mm focal lengths (35mm equivalents, in the case of digital cameras). These will gather lots of light and allow shallow depth of field results. The wide angle is great for group shots and puts performers into context on the stage.

Portrait lenses, say 100mm f/2 or f/2.8, are also great. You'll probably be close to the stage, so these will give you good head-and-shoulder shots. If you can afford it, go for a wide-aperture zoom; it'll help you compose the shot precisely even if the performer is moving around fast.

Enhancing Stage Shots. Often the scenes from a performance can be improved by enhancing some of the theatrical elements. One way of doing this is to make the spotlighting more obvious.

Here are some scenes from the production *Ovo*, by Peter Gabriel. Performed on the enormous circular

These shots of Peter Gabriel's *Ovo* were all recorded using an automatic digital camera with 3x zoom lens (Fujifilm MX2900). Autoexposure has been used with only modest post-production corrections.

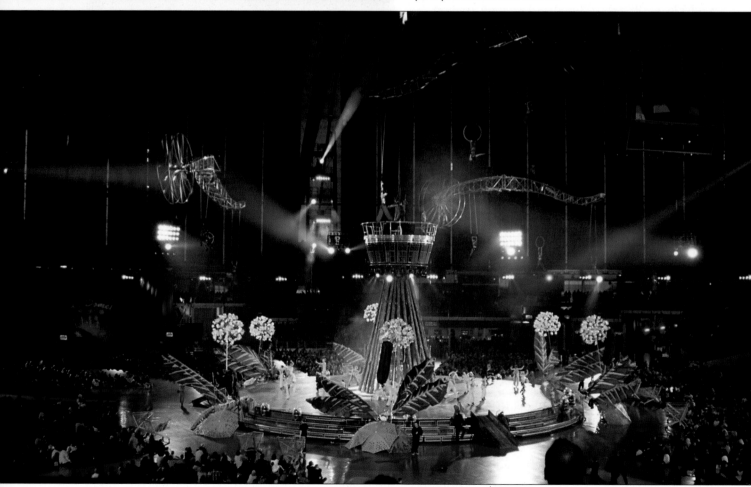

Extremely low lighting meant a wide aperture and short shutter speed for this stage shot. The result lacks critical sharpness. However, if we increase the contrast slightly and then add noise (Image>Adjustments>Add Noise) we get an atmospheric result that successfully conceals the lack of sharpness.

stage at London's Millennium Dome, visually and conceptually it's very similar to a Cirque du Soleil show. Like so many spectacular performances, even the most dedicated of photographers can become overwhelmed by the scale and exuberance of the event and end up clicking in all directions. This is one show I had to see three times before becoming a little more judicious about my photography.

It is clearly important to record images that relate the scale of the whole production but too many shots like this, as only the details changed, would quickly bore any potential viewers. We need to juxtapose these scenes with detail shots, such as those of the aerial performers, and spot-lit lead actors.

◼ CHRISTMAS

Even if you don't celebrate it in a religious sense, there's no doubt that Christmas provides some of the best and most concentrated photo opportunities.

The combination of short days, long nights, and spectacular illuminations can make this one of the busiest and certainly most rewarding times for the low-light photographer. Outdoors, indoors, city and township, the whole world seems to take on a new identity if only for a fleeting few weeks.

The celebration of mid-wintertime by lighting the darkness is, of course, not exclusive to Christianity—many religions and cultures feature luminous festivals at this time. Think of Hanukkah, Diwali, or Eid. A celebration with light is pivotal to each. If we go back far enough into our own prehistory before organized religion began, we will find a more secular need for and celebration of light: warding off the unknown.

But there's no doubt that, in the western world at least, it's Christmas that offers the most celebration. As the year rolls towards an end, city streets take on a new dimension and residential districts, too,

ABOVE—There are so many opportunities at Christmas it's hard to know where to begin or where to stop! Even a simple cake decoration can make a charming image—this one was illuminated using a simple desk lamp. RIGHT—Even store-fronts take on a more photogenic aspect around Christmas. This cameo featured in a department store window.

become resplendent with countless luminous garlands. Being circumspect and, dare we say it, a little more forthright, we might say some of these displays tend towards the garish and kitsch but, in the spirit of the season, we come to love them all. And what great photo opportunities there are even in the most eclectic of displays! Indoors, whether domestic, commercial or retail, there are even more.

Street Illuminations. Whether the illuminations are commercial or residential, the best time to photograph is around dusk. At this time, we'll still have some blue color to the sky, whether clear or cloudy. Leave it until a little later and the sky will be darker or, worse, will have taken up the pale amber glow of a million streetlights.

It's the big cities that offer the best street displays by virtue of scale and economics. Think of Fifth Avenue in New York or Regent Street in London. You can be guaranteed an exemplary display in either. But even if you live in somewhere less cosmopolitan, it's easy to find a good display. Not as extensive, perhaps, but equally photogenic.

It's not just the streets that are better dressed for the festive season; storefronts too can become the subject of our attentions. Let's face it, unless it boasts some architectural curiosity it's unlikely that you'd

turn your camera towards stores themselves—but as commercialism reaches its annual peak, you'll often find store windows become less self-conscious and more fun. Seasonal displays make for great photos and, as they are lit brightly to attract attention, they can be photographed with comparative ease.

Sometimes store windows make for great shots when viewed in isolation; sometimes stepping back and including passers by adds context to the shot. Because the nights draw in so early in winter (in the northern hemisphere) and stores tend to be in busy parts of town, it's often hard to escape the onslaught of pedestrian traffic, so make a feature. Set your camera on a tripod (taking care not to cause obstruction or contravene any local bylaw) and take a time exposure. Anyone passing the window will be rendered as a blur giving an added dimension to the image.

Street illuminations, and those adorning homes, require longer exposures. As a guide, I'd suggest a

starting point (with the camera set to ISO 100 equivalent) of 5 seconds at f/8—but do be sure to bracket. Discrete lighting, featuring lots of individual bulbs, can benefit from the addition of a starburst filter. These filters render every highlight as a two-, four-, or six-pointed star. The star effect tends to get increasingly prominent as you reduce the aperture.

Just as an aside, you don't have to wait until Christmas to record street illuminations—the same rules apply to any street lighting. If you're lucky to live in Las Vegas or near Downtown Disney in Florida, you can be taking shots like these all year around.

In the Marketplace. If you are lucky, you may find a Frost Fair or Market visiting your town. Often of German origin, these specialize in Germanic produce along with unique Christmas gifts. Marketplaces are great places for candid shots of people, but the seasonal nature of these fairs adds more interest. Close in on products on sale—Austrian glass and artwork make for great shots. Equip yourself with a zoom lens to make sure you can isolate specific parts of the scene.

Christmas Trees. They tend to symbolize the season in a way that has become virtually clichéd—but still, Christmas trees are great to photograph. There's rarely a shortage of candidates and, rather like sunsets, no two are ever quite the same. Unlike sunsets you won't be up against the clock when shooting, so there is plenty of time to get the composition and exposure right. If there's a tree in your own home you

can even use it as an impromptu studio set to experiment with different techniques.

For example, you can shoot it using only the fairy lights decorating it. Or mix this lighting with subdued room lighting. Set your white balance to Auto in this situation so that you'll get the best setting for a mixed lighting source.

You don't have to include all the tree in your shots. Close in on some of the details. Closeups of baubles make for wonderful images (though watch out for your reflection in glossy metallic ones!) and

Tree decorations make great subjects—and are ideal for making personalized greetings cards for next year.

could be used as the basis for some personal greetings cards next year. And don't be afraid to adjust the position of the decorations for your shots—though if it's not your tree, ask first!

A tree can also be a perfect prop for some seasonal portraits. Children sitting expectantly around the base of the tree, even if obviously posed, will make wonderful shots that Grandma will treasure the year round. Use wrapped Christmas presents around the base of the tree to hide any unsightly mounting for the tree, or wrap it with some satin or other glamorous cloth. An eye for detail is important at this

Brush effects are great for Christmas images. Here, the original was of very low resolution (less than 2 megapixels). On its own, it would not stand much enlargement, but by applying the Crosshatch filter we were able to deliver a larger image.

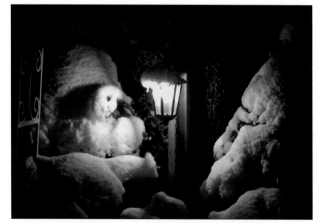
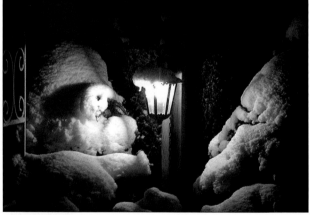

Initially uninspiring scenes can give intriguing results with a little manipulation. This shot of an antique lantern surrounded by snow-laden shrubs has been tinted by painting green into a new layer. Changing the layer blend mode to Color it gives a convincing tint effect. Adding a few red spots with a fine paint brush even gives the impression of holly or Yew berries!

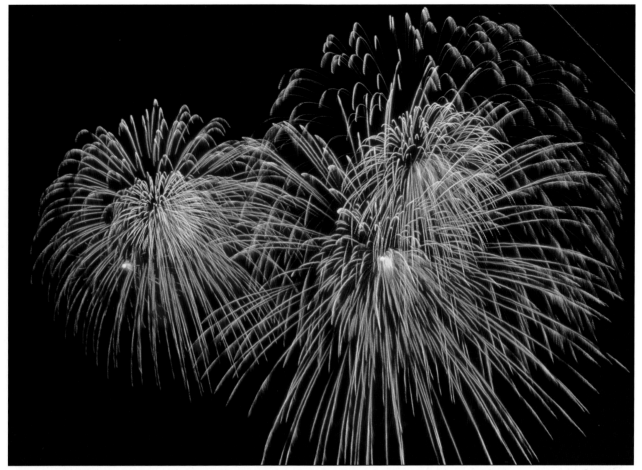

Skybursts are the most impressive of displays. Timing is critical, both to capture the show at its peak and to get a sufficiently long duration to maximize the visual impact.

stage, because it saves a great deal of time later when we come to tidying up our images on the computer.

Outside, in the evening sun, trees capture the essence of the season and help date your image.

Christmas Morning. Even stripped of religious connotations, Christmas morning is a magical time for children. For the parent photographer it can be equally so. Children unwrapping presents makes for wonderful candid portraits. Doing so in full room lighting or using a flash can ruin the mood and doesn't allow you to capture them off guard. So ramp up your ISO speed as high as it will go and shoot away!

Statistics show that, after summer vacations and weddings, Christmas is the most popular time for photography. With just a little practice and some imagination, the images we record can be as special as the time of year. Precautionary notes? Winters are generally cold so make sure you keep a good supply of batteries to make sure your shooting can carry on for as long as possible.

◼ FIREWORK DISPLAYS

Photographing fireworks will test the mettle of any camera—digital or conventional. They are transient, set in a dark sky, and a mix of extended and point light sources. Unpredictable, too. There's no way you can expect even the most complex of metering systems to cope. Normally, given this set of variables, I'd say "bracket exposures" or "try exposure compensation," but I'll have to come clean here and say that firework photography is often more a matter of luck than it is planning.

Preparation. Okay, so planning doesn't necessarily pay the same dividends as in other forms of low-light photography, but it is still important to ensure you are fully prepared for a show.

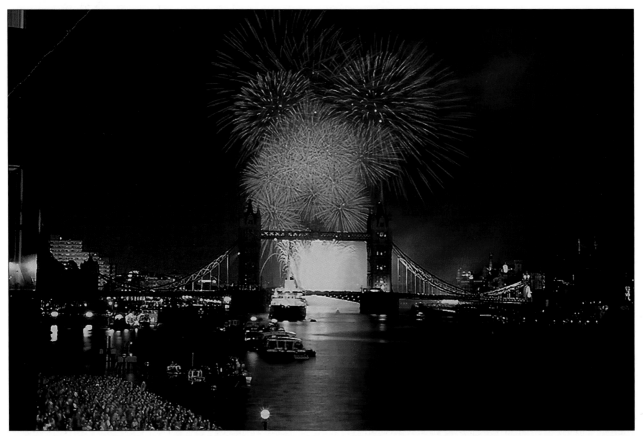

For the ultimate, go for shows in urban landscapes. The buildings and bridge here, in this millennium show in London, give a sense of scale and add dramatic interest.

First, make sure that you arrive at a show early and can pick your position. Some displays are aerial and it makes little difference if you can see the launch point or not. Others will feature ground-level displays that you will want to include. Some aerial displays will be set against foreground objects the inclusion of which will further enhance images. By arriving early, you'll be sure to get a pick of the best shooting locations.

Make sure your camera is ready, too. It'll need to be tripod mounted as most of the shots will be of one-second duration or longer. Handholding just doesn't work! Set the focus to infinity and, if you can, lock it there. There is enough light in a skyburst to allow autofocusing to work, but by the time your camera has locked on to the event, it's just about over!

This could be a good opportunity to use your camera's multiple-exposure or burst mode to take multiple consecutive shots. Conventional cameras' motordrives make it possible to shoot continuously for as long as the film will hold out. It's not quite the same with digital cameras—it takes a finite time after each shot to record the image to the memory card. Nonetheless, quite a few models feature a buffer that allows several shots to be taken consecutively without any delay. Some models also feature continuous shooting where only the last four shots are retained. The idea is that you press and hold the shutter during the action and release immediately at the end— as a skyburst rocket reaches its full glory for example. Then, the last four shots prior to this point are retained in memory.

Whatever the mechanism, multi-shot techniques can give you added assurance about capturing "the moment."

Exposure. Time exposures of fireworks are essential. Instantaneous shots are possible, but tend to produce snapshot images that don't really convey the essence of a firework display. The time exposure

ensures we record the motion and a complete record of an event. Though it is tempting to treat a display rather like lightning and keep the shutter open for 30 seconds or more, this can be ruinous to the image quality due to the build up of noise in the dark parts of the image. Keep your images to shorter durations (one to four seconds is an ideal range). Though you may not record many fireworks in this time, there are tricks we can employ to make it look as if we've caught more. We'll come to this later.

Unlike many nighttime subjects, where there can be a wide latitude of exposures that give an acceptable result, it is easy to overexpose and lose the delicate detailing that defines much of the form. So keep the apertures down to around f/8. Of course, the absolute brightness varies considerably between different fireworks—and the brightness is also a function of the distance from the display. Check your first shots and be prepared to open or close the aperture by one stop either way to improve the definition. Working with a low aperture like this also ensures that if you've set the focus range to infinity, shots of fireworks in the middle distance will still be pretty sharp.

Noise. Digital noise can become more visible in firework shots than with virtually any other subject. This is due to the comparatively long exposures and the black sky; under these conditions, any electronic fluctuation will produce a tiny bit of noise that very quickly becomes visible. As noise is related to the sensitivity of the imaging CCD, it makes sense to keep the ISO as low as possible; 100 or 200. Anything more will exacerbate the buildup of noise.

You can also reduce the visibility of noise by choosing the highest resolution to record your images. Choose the storage format that involves the least image compression, too. If you can store images in RAW format, this is ideal; if not, select the least compressed TIFF or JPEG. Compression will increase the appearance of noise and, with the transient colors of fireworks, can adversely affect the color balance. The only caveat is that low compression (or no compression in the case of RAW images) will mean that image file sizes will be large, so you need to ensure that you've got sufficient capacity to last you through the show!

White Balance. Ensuring that the white balance is set to daylight (sunny) will help reduce noise and, fortunately, also improve the color fidelity of the firework images.

Capturing the Show. Once the show gets underway, you'll probably find you throw caution to the wind and shoot away continuously—as we mentioned, success often comes down to luck, so this isn't all bad! But a little method will ensure a greater degree of success.

Begin by shooting in wide-angle mode. This way, you'll be sure to catch all the explosions and you'll have a chance to gauge where and how each burst occurs. Then, when you can predict where to point the camera, you can zoom in a little.

If you've set the camera for multiple shots, now's the time to take advantage and let the camera fire away. You'll probably find your memory card filling at an alarming rate—which is why we suggest that you make sure you have ample capacity at the outset. You'll have an opportunity to change cards every so often, but it's unlikely that there will be a sufficient break in the proceedings to enable you to review and reject any unsatisfactory shots to regain some memory space.

Firework Montages. Here's a simple way to get a composite—or montage of several fireworks. It uses our old friend the blend mode. This makes the presumption that you have used your camera on a tripod and that your have changed neither the position nor the lens focal length between shots.

To begin, open an image. Then, copy subsequent images into new layers on the first image. If you have a lot of images to choose from, go for the best and also those that illuminate different parts of the sky.

Then, change the blend mode of each layer from Normal to Screen. As you change the blend mode of each layer, you'll build up a busier and more complex skyscape. If you don't like a particular layer, or it doesn't seem to work in the context of the composite you can turn it off by clicking on the eye icon adjacent to the layer.

5. People

All we have said about the atmosphere low-light photography conveys applies also to the use of low light for photographing people and taking portrait shots. By using available light, we will get more natural results, whether we photograph people in their own environment or do so in a more formal portrait setting.

We often view people in the street as a nuisance, a distraction or an obstacle to getting a clear shot of a building or feature. But people are as much a feature of our cities as are the buildings. So why not view them (if you forgive the pun) in a new light? People can make great shots in themselves. Think about those street performers, the ebulliently dressed, or folks laden down with boxes as they battle winter closeout sales. All manner of expressions can be found, from humor through pathos and even agony.

Character studies are where many non-photographers connect with us; the public in general seem to prefer pictures of people to those of landscapes. The interest level can rise even more when we see interesting people in the context of their workplace or home. If you know some artisans or craftsmen, photographing them in their workshops or displaying examples of their work can say much more than a simple portrait.

Modern decorative lighting and even illuminated toys can, when matched with a camera of appropriate sensitivity, make for unique portraits.

LEFT—Using the ambient light in an interior portrait study can be problematic, since the light levels can be unacceptably low—but with a little luck, great results are possible. RIGHT—Impromptu street portraits can lead to great character studies.

In the studio, there's a technique that has long been used to emphasize character by using low light levels and careful placing of the light that is used. It's called low-key portraiture and is often more powerful than its better known cousin, high-key portraiture, a technique that uses high lighting levels to produce romantic images.

Over the next few pages we'll take a look at how to approach candid street photography and then extend our techniques and knowledge to taking portraits of people indoors. After a brief excursion into the world of low-key portraiture, we'll take a look at possibly the most evocative of light sources for portraits—yet one we use too little: candlelight.

■ STREET PHOTOGRAPHY

From the 1960s on, the Russian photographic industry produced a range of low-cost SLRs that launched the careers of many photographers. Among the eclectic mix on offer was an SLR coupled with a 300mm lens called the Photosniper. Viewed from even a modest distance it looked to all the world like a rifle, complete with sight and shoulder brace.

Could you imagine, given the security issues so prevalent in the U.S. and Europe today, the implications of using one? Security services would, at best, apprehend the hapless photographer and, at worst—we'll you don't need me to be explicit on that one.

Where's all this leading? Well, candid street photography used to be a harmless activity that could produce great photos that said a lot about contemporary society. Now, even though surveillance and security cameras are abundant, people are more reserved—or perhaps we should say *concerned*—about being photographed and are more likely to challenge any casual photographer.

Small is Beautiful. With this in mind, tiny (or at least compact) digital cameras come into their own.

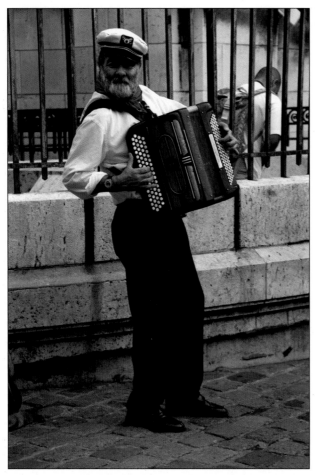

Though this busker is staring straight at the camera, it makes a perfect study. The wry smile is due to the few Euros thrown into his collection!

Point an SLR camera at someone and there's no hiding place. Yet, with a small digital camera, not only can you be more discrete but you are less likely to be identified as a photographer. You are more likely to be a passer-by showing off a fashion accessory!

In a sense, we are following in the footsteps of some of the great social and reportage photographers who would eschew the latest all-singing, all-dancing SLR designs for more compact rangefinder models. These were more discrete and quiet—ideal for the unobtrusive photographer.

Street photography encompasses a range of opportunities. At one end it is merely an adjunct to cityscapes—with people adding a sense of scale and place to otherwise clinical city landscapes. At the other it is character studies. In between are a wide range of overt and covert subjects.

Time of day? Any. But as the streets at night tend to bring out people in a more relaxed mood—unwinding after a long day's work—you'll probably find the most promising subjects are on the move then.

Shooting from the Hip. You've probably heard the phrase before, but now here's your chance to do it for real! If you are serious about capturing people in a natural way, unaffected by the camera, you don't even need to bring the camera to your eye. Just hold it casually at waist height an point it in the right direction. Autofocus, autoexposure, and a wide angle of view should accommodate any misalignment. You will need to ensure that the camera is pre-set (with flash off, an appropriate metering mode selected, and the lens set to a suitable focal length, if appropriate).

Another candid technique is to work with a friend. Get your friend to stand close to where your action is, but slightly to the side. When you're setting up the shot, you make it obvious that you are photographing this obliging subject, but at the crucial moment of exposure you tilt the camera slightly and shoot the true subject.

Of course, not all photography demands such covert tactics. Street performers and buskers make great subjects, and intimating that you'd like to photograph them will usually be acknowledged with an accommodating smile. Reciprocate with a donation and you might even get an encore!

As the night draws in and people reach that more relaxed state, you'll find they are more amicable to photography and will adopt impromptu poses—often without being asked, just on the sight of the camera. Take advantage of this; a camera shooting away—even with flash—lowers the general threshold of resistance and you'll be able to get away with taking more photos. And if you look to be one of the revelers yourself, so much the better.

In fact, as you are shooting away, you'll find that others around you are doing much the same—thought not necessarily with the same degree of serious intent as yourself. Such is the increasing pervasiveness of digital cameras that many party-goers and

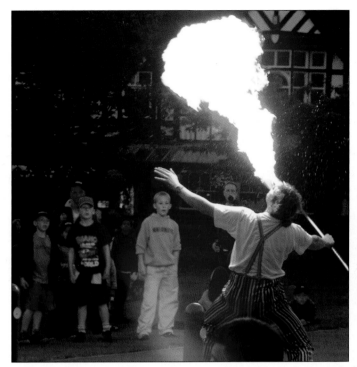
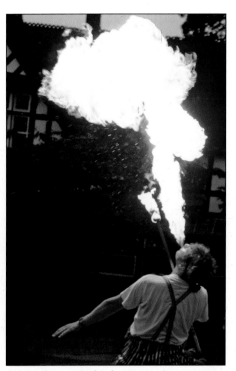

Fire eaters are not a common sight on every street, but when you do find them they make for fantastic photo opportunities. The great thing is that, even here in the late evening, the light from the fire is sufficient to illuminate the scene. A Fujifilm S2 Pro with 80mm lens has been used here with the exposure approximately $\frac{1}{125}$ second.

In this Parisian square, artists paint landscapes and portraits and sell their work directly to the (mainly) tourists. But the artists themselves make great subjects, too.

people out for the evening want a simple record of the event.

Safety First. Even with our discrete cameras, it pays to be vigilant—especially when photographing in public at night. Your camera is an attractive proposition for the opportunist thief, so keep it firmly in hand and take care in more colorful locations. Some characters will play to the cameras but others may take exception. If in doubt, err on the side of caution and resist the urge to shoot even if it is from the hip.

When travelling, it's not always the most obvious locations that deliver the best shots. These Venetian Carnavale performers were resting away from the crowds. Photographed at canalside, it's a stunning composition.

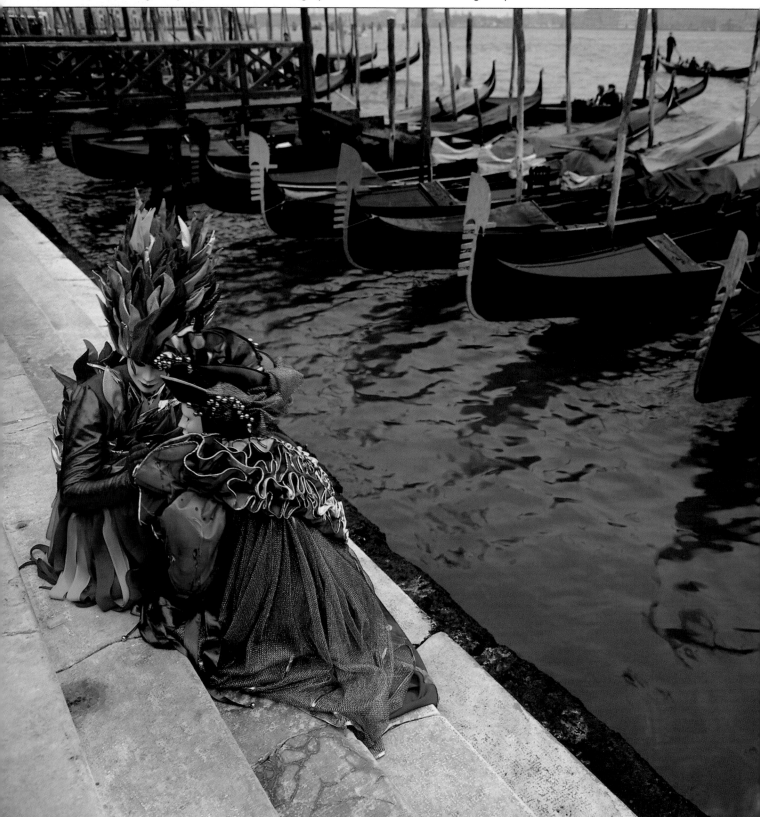

◼ THE MAGIC OF CANDLELIGHT

Candlelight is an exceptional light source. As well as being dim, in comparison with more conventional lighting sources, it radiates a warm and gentle glow that gives a unique quality to any subject illuminated by it. Portraits take on a romantic look (no matter who that portrait may be of!) while interior shots take on an aspect quite unlike that they adopt under incandescent or flash light. Lit candles can also make wonderful still-life subjects.

Of course the atmosphere of candlelight comes at a cost and that cost almost needs no comment: candlelight is very dim. You can't augment candlelight with any other lighting source either without compromising the quality. And if that were not enough to put you off the whole concept, candle flames can act like point sources and produce unwanted flare, even with optics of the highest grade. But don't be put off. With your first successful candlelit portrait behind you, you'll never look back.

Preparation is essential for a candlelit portrait. To begin, make the best of the light available by placing your subject near a bright wall. An off-white color is best, as it is less harsh and produces less contrast than white. Have your sitter move close to the candle and position yourself sufficiently close to get a good head-and-shoulders portrait. Keep in mind that the light from any source falls off in inverse proportion to the distance (this is called the Inverse Square Law), so if you double the distance between your sitter and the candle, the light level upon him or her will be one quarter. When you don't have much light to begin with it makes sense to hang on to every bit you have!

You can improve the illumination levels by a little trickery. Position some more candles just out of the frame on the same side of the scene as the illuminat-

The light produced by a candle may be dim, but is unique in its nature; it delivers a warmth that is hard to duplicate in any other way.

ing candle. You can also place a reflector behind the candle to redirect onto your subject some of the illumination that would otherwise be lost back into the room.

As for camera settings, with candle-lit portraits you can't simply select f/8 and ISO 200 equivalent and then expose for a time to match. If you do, you'll end up with an exposure of quite a few seconds. Even the most patient and static of sitters will

In contemporary Christmas decorations, neon and LCD lights have taken over from candles in many illumination roles. Keeping safety to the fore (this is an outdoor grade low-voltage lighting system) you can use them to produce quite different portraits.

in contrast, but this no different from using fast film and, in the context of candlelit portraits, this tends to work in our favor.

If you are using an SLR camera, select a prime lens rather than a zoom. Unless you've spent a king's ransom on your zoom collection, these lenses tend to be rather slower than prime lenses. A 50mm prime lens on a digital SLR is generally equivalent to a 75mm lens on a 35mm camera and the wide aperture of f/1.8 or f/2 will be ideal. Just take care that you focus well; with wide apertures, you will not have much depth of field. Focusing at this light level is best done manually, as autofocus mechanisms will either balk at the prospect or give an incorrect result. Focus on the sitter's eyes, and if they are at an angle to you, focus on the closest one. This is the point that our eyes are drawn to in the finished portrait, so it's where we will notice any lack of sharpness. It should now go without saying that you should have your camera on a tripod—first because of the duration of the exposure and second because it helps ensure pin-point accuracy with the focus.

Overcoming Contrast. A problem of taking a still-life shot that features lit candles is that the flame is quite a few orders of magnitude brighter than the body of the candle and any surroundings. Of course, for a still life like this you could introduce some subsidiary lighting. Tungsten room lighting could help because it is notionally of the same color temperature as candlelight. This gives you the chance to play around with different color casts, use low-speed (and therefore comparatively noise free) shooting, and avoid any potential flaring

have moved, if only a little, in this time and the portrait will be spoiled. Instead set your camera to the highest ISO—even 1600, if you can manage it. These high speeds, as I've remarked elsewhere, tend to give noisy results and often give a slight reduction

DIGITAL VIDEO CAMERAS FOR STILL IMAGES

There was once a very obvious demarcation line that separated still photography and movie photography. Whether recorded to film or video, the resolution and fundamental nature of moving images has been considered inferior to still images. Of course some film stock—35mm and even 70mm—is similar to or better in quality than that used in still cameras, while the cameras used boast optical quality that is a match for any camera. It's the method of filming—featuring subject or camera movement—that makes it inappropriate, in general, to use individual frames for still photos.

More recently, with the advent and continued development of digital video systems, that demarcation line is being (albeit slowly) eroded. The erosion is strongest in low-light photography. Some digital video cameras can produce movies under very low light conditions; others in almost total darkness. Under the most unfavorable conditions, images take on an unworldly green hue (reminiscent of those shots using image intensifiers) or are monochrome, but nonetheless faithfully record scenes. These are, admittedly, the

You need to review your video footage frame by frame to get the best shot. The great thing about using video is that you've captured so much of the action you can be spoiled for choice.

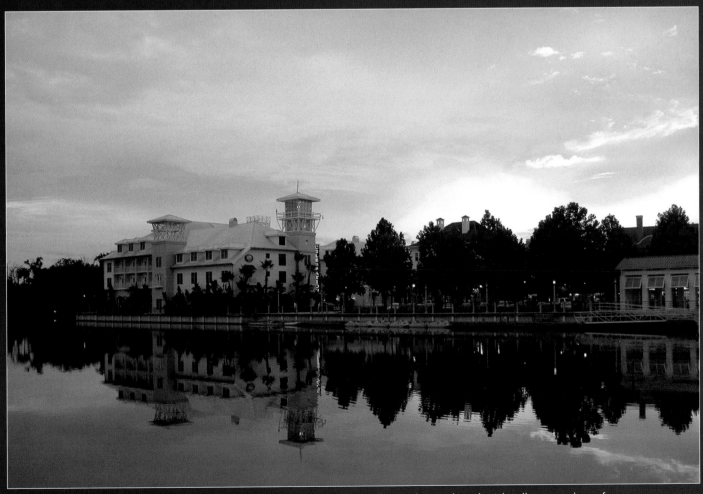

The still image mode offered by the latest digital movie cameras gives surprisingly good results. Like all images direct from a camera, you may need to take some remedial action in an image editor to bring out the best in the image. Check out the excellent shadow performance in this shot.

most extreme situations; but digital video cameras can also be useful for rendering images where the light levels are just too dim to successfully use your still digital or conventional camera.

Getting still images from a digital video camera can be simple. Some models have a snapshot mode that uses the full resolution of the imaging chip in the camera to record a still image. This can have a commendable resolution of 2 megapixels or more. Recorded images are stored to a memory card, just in the same way that images are recorded in a digital still camera. When you get back to your computer, you can hook up the camera or stick the memory card in an appropriate reader.

You can also extract still images from standard video footage. You'll need to import your footage first into an application such as Apple's iMovie or Adobe's Premiere. You need to be very selective when choosing a frame; all that we said earlier about the fundamental differences between movie and still footage still applies. You'll need to review your movie frame by frame to find one in which image sharpness is not compromised by movement. Then, extract frames by choosing (in the case of iMovie) File>Save Frame As and your chosen frame is saved as an image.

Don't expect results of the highest quality when extracting images from digital video; the resultant images will be of comparatively low resolution even if the imaging chip itself has a respectable resolution. You won't get anything much better than VGA (640 x 480 pixel) results. But if the choice is between getting reasonable images or nothing at all, or you only have video footage as the record of an event, the effort—and the results—are certainly worthwhile.

VGA image quality is not the best in resolution terms but is more than ample for web-based work. When printing, try to limit the size of the image to prevent the low-resolution nature of the image becoming obvious.

due to the bright light source. It's also ideal for environments where you have very little control over the lighting conditions.

Enhancing and Simulating Candlelight. You can even enhance the candlelight or simulate it entirely. Circumstances permitting, you can regard this essentially as a studio setup and arrange your lighting, from whatever sources you choose, to provide the best illumination. You could do this using studio-type lights, a flash, or, for a more sophisticated illumination, a mix of flash, room lighting, and reflectors. Be sure to preview your results on the LCD—particularly if you are using flash.

Now for the fun part: we are going to use Photoshop to add the candle flames. Begin by using a soft, cream-colored paintbrush and drawing in a flame shape. You don't have to be too precise about this operation; you can use the Blur tool to make the shape much softer still. Build up the flame gradually so that you get just the shape you want, and one that looks realistic.

Next, you need to lighten the image selectively to simulate the lighting effect of the candle flame. The best way to do this is to use the Dodge tool. Select this tool and a large, soft-edged brush. Set the Exposure to around 5 percent. This means that you'll be applying a very gradual amount of lightening. Brush down the candle, watching the lightening effect. For successive strokes, don't go so far down the candle. This will give you a graduated effect, with the top of the candle (the part nearer the flame) appearing brighter.

Digitally lighting a candle. For authenticity, note how (in addition to the flame) the stem of the candle was also brightened—and for added panache given a mild amount of lens flare, typical of what we might expect given the brightness of the other elements of the scene.

6. Tools

*E*xpertise in low-light and night photography comes through developing good technique, but there's no disputing that to extol good technique you need the best tools that you can afford. That means cameras, lenses, and, especially in this genre, good supports. We also need to consider what methods we can use to enhance and add to the ambient lighting in our scene.

Through this chapter we'll take a look at cameras and the features that make them best suited to our particularly demanding form of photography. It's often a case of horses for courses. It would be convenient to dismiss conventional cameras as old-hat but, as we'll see there is still some mileage in our old models. No need to consign them to the garage sale yet!

Successful night photography is all about making the best of the available light . . .

Successful night photography is all about making the best of the available light, capturing and gathering as much as possible. The holy grail is a set of wide-aperture, optically precise lenses. Few of us, given the prices of such exotic optics, will be shopping for these, but there are a few simple rules we'll examine as we make our lens selections from those on offer in the less rarified part of the market.

Where digital technology does score is in the darkroom. It's funny how that term has lingered on in a world where all stages of photography are conducted in the light. Image-editing software applications are key to making a success of our images, whether digital or conventional in origin. We can easily make costly mistakes when it comes to buying software, so we'll take an objective look at those applications that will augment our skills and give short shrift to those that don't!

◼ CAMERAS

From the earliest days of digital cameras, designers and manufacturers have been freed from the shackles that were imposed by the need to use film. With no need to consider building in a film path (responsible for the characteristic size and shape of most compact and SLR cameras in 35mm and APS formats), designers could go on flights of fantasy with their designs.

Very quickly, though, many of the more fanciful designs fell by the wayside. They may have been great to look at and proved popular for the fashion conscious, but in terms of photographic merits they were less well received.

As time went on, it became quite clear that the conventional film-based layout was not only necessary but also desirable; the size of a camera is dictated by ease of operation and, similarly, the shape by ease of use. In the end, being able to hold the camera steady and operate the controls efficiently is just

Cameras today come in many forms. Used with care, each is capable of low-light photography.

as important with a digital camera as it is with a conventional one.

Where we continue to see variance, and to a degree innovation, is in the classes of cameras. Digital technology has broadened the scope and reach of cameras, making it possible to satisfy the needs of many more potential users than has been the case in the past. The result of this is that we can place all existing cameras (and many future models, too) in one of four categories:

- Fashion/gimmick models
- Compact models
- Hybrid/enthusiast models
- Professional and semi-professional models

Cameras in each category can produce images in low-light and night situations, but it is important to understand the limitations. Also, many professional and enthusiast photographers have cameras from two, three, or even *all* these divisions and use each, appropriately, with equal vigor! Let's take a closer look at each and their key competencies with regard to low-light work.

Fashion/Gimmick Cameras. It's easy to dismiss this category as the last bastion of the wacky designer, but these cameras have an obvious benefit that they are generally very small, very portable, and easy to carry with you everywhere. Photographers often criticize these cameras on account of their low resolution and poor controls, but given that the target market is not *photographers* but non-photographers who want to take "memory photos," these issues are not so important. In fact, many of these cameras now offer resolutions sufficient for reasonable-sized prints. The only black marks are the lack of control and, in many cases, the lack of an LCD screen to review shots. Low-light performance? Often the limited controls will work in your favor. Because the aperture and shutter speeds are limited, you'll be able to capture great sunsets and illuminations—often at optimal exposure.

Compacts. Compact cameras have been with us for a long time—they are the spiritual descendants of early Leicas—and flourished through the 1980s and 1990s with ever higher specification and performance. Specifications became so good that compact sales impacted heavily on SLR cameras and also created a new market segment for non-enthusiast photographers who wanted great photos. In digital guise, we can now choose from almost countless models that offer point-and-shoot simplicity through to rather sophisticated models that provide a convenient, pocketable back-up to the enthusiast's more substantial models.

Midrange compacts have good low-light (and night) capabilities. If you are considering one for your main camera or as a secondary, check the specifications. Does the camera focus well at low light levels? Can you override the autoexposure? Does it have a range of flash modes? Over- and underexposure controls of up to two stops are essential.

Despite the marketing concentrating more on the fashion value than the photographic quality, these cameras from Fujifilm and Sony can deliver commendable results.

Canon's PowerShot compacts manage to keep dimensions small but still pack a tremendous number of features, many of which are essential to the low-light photographer.

More compact than an SLR with most of the virtues, hybrid cameras are well specified and most offer images of the highest resolution. Fixed lenses can be a limitation requiring the use of inconvenient supplementary lenses for long telephoto or wide-angle shots.

Hybrid/Enthusiast Cameras. There was once a clear demarcation line between cameras designed for the serious user and the more casual user. That line has become particularly blurred in the digital arena. The category we now describe as hybrid/enthusiast has been determined more by price and performance issues than any other feature.

The evolution of digital technology initially placed digital SLR cameras very much in the rarefied territory of the professional. Those that spend their own money on cameras, however, could rarely justify such expenditure. This gave birth to the so-called hybrid cameras. They boast SLR-like handling but have fixed (rather than interchangeable) lenses and viewing by an electronic viewfinder rather than conventional through-the-lens system. This makes for a comprehensively specified camera at a price point similar to top-level compacts. It is likely that, with the price of digital SLRs falling, these models will get squeezed out of the marketplace but, for the moment at least, they offer great performance at reasonable price.

That great performance means they are ideal for low-light work. You'll generally find all the photographic controls that you need and an exposure system that makes it comparatively simple to get great night shots. Many models also allow the connection (via cable or hotshoe) of an external flash (or flash system) for even more creative results.

Professional and Semi-Professional Cameras. When money is less of a determining factor, you can have the full control and flexibility offered by a digital SLR camera. That's not to say that the entry point into this field is prohibitively expensive.

Canon's EOS 300D brought full SLR versatility to the photographic masses, making digital SLRs a viable alternative to the conventional SLR for the first time.

Aping professional film-based SLRs, digital models give all the flexibility and performance that the most demanding professional user expects. The Hasselblad H1, shown here with a Kodak Professional digital back, is unique in that it can accept both digital and conventional backs.

Canon's 300D model brought digital SLR technology to the masses (or the masses of enthusiasts) and proved to be an immensely competent performer. At the other end of the scale, Hasselblad's H1 model permits the use of conventional or digital backs. In digital form, the camera bears a pretty hefty price tag—but it boasts performance and control to match.

These cameras, without exception, will give you everything you need for taking any type of low-light or night photograph. The ability to change lenses, add external flash systems, and even develop new shooting programs makes great shots a cinch. You'll also find that features such as outstanding autofocus performance that lets you focus precisely, even in conditions of virtual darkness.

■ CAMERA CONTROLS: REVISITED

I'm not going into the detail of what every control is and how it operates; it's just that, in low light, some of our familiar controls take on new significance, while the behavior and operation of others may need to be modulated.

Automatic Controls. The camera technology that underpins most digital models is derived from that of 35mm compact cameras of the late 1990s. As

such the foundation is camera processors that feature a high level of automation and the ability to get great shots under a wide range of conditions. When we talk about the 'Auto' mode on a camera what do we mean? The camera will have:

- **Autoexposure**—The "correct" exposure for every shot will be calculated and set
- **Autofocus**—The element of the image you determine (and place) as the subject will be in sharp focus.
- **Automatic Flash Operation**—If light levels are low, the on-camera flash unit will fire and give a precisely determined amount of light.
- **Automatic White Balance**—The color balance of the shot is automatically adjusted to deliver an image that is optimally corrected a neutral color balance.

It's true that many camera users, digital and conventional, never venture beyond the automatic mode—even if their cameras offer substantially more in the way of options. There is really nothing wrong with this approach. The majority of camera users (rather than photographers) want to record their

vacation, a party, or family event unencumbered by technology. The automatic mode allows this.

Sadly for the night time photographer, using the "auto everything" approach is more problematic and, unless time is limited, it's pretty near essential that you use more sophisticated options on most occasions. I say on "most" occasions, because you'll probably be surprised how effective the automatic mode (with just a couple of conditions) can be.

Auto-Enhanced Features. If we eschew the fully automatic mode as being too proscribed for our purposes, we need to delve a little deeper into the camera's controls. I'm using the term "camera" here rather glibly. As we've just discussed, there are many levels of complexity in a modern digital camera, so these descriptions of controls and their use will apply only to appropriately endowed machines.

The term "auto enhanced" describes controls in which you can set one parameter and the camera will silently adjust corresponding controls until you get the right result.

For exposure, many cameras offer Aperture Priority and/or Shutter Priority modes. You set the aperture or shutter speed respectively and the camera will set the corresponding shutter speed or aperture required to get a perfect exposure. This is ideal if you want to force the camera to deliver a small aperture (to get a wide depth of field, for example) or you want a long shutter speed (say, to blur moving objects).

In either case, the camera will configure the overall exposure to deliver an image that, if all the light levels were averaged, would be median gray in color. This helps explain why, when you shoot a snow scene dominated by whites and light colors, the results can be dull and disappointing. More significantly, it means night shots can often be washed out, as the camera tries to achieve its median-gray level.

Enter Exposure Compensation. This control lets you vary the exposure set by the camera and produce results that are lighter or darker than the camera's central processor would automatically deliver. Graduated in stops (often from a range of +2 through –2, in one-third or one-half stops), dialing in a compensation of –2 is a great place to start for your night work.

Focus Lock. Focus lock, a distinct button or a feature enabled by light pressure on the shutter release, locks the camera's focusing system. It's useful when a subject is not placed centrally in the viewfinder. You can focus on the subject, lock the focus, then alter the composition. It's something you tend to do

CONVENTIONAL CAMERAS

It might sound a little incongruous—in a book about digital low-light and night photography to introduce conventional cameras as tools, but there's no denying that these too have their place. Digital cameras have many strengths and have eroded many of the virtues by which conventional cameras were judged superior. But there are some elements of photography for which the use of a film-based camera is still ideal. After all, we are intent on creating great pictures and we're not going to let dogma cramp our style!

This really isn't the place to discuss the relative merits of conventional cameras; and I'm not necessarily suggesting you rush out and buy one. However, many of us who began our photographic exploits when digital photography was in its infancy can still boast a good collection of non-digital equipment. Why not use it? If you have an SLR with a good collection of lenses, doesn't it make sense to capitalize on your investment by adding a digital body?

Though we'll be shooting on film, this does not preclude us from embarking on any of the digital techniques explored here. All you need to do is to ensure that your film, transparency or negative, is digitized so it can be edited on your computer. You could do this yourself, taking advantage of the prolific range of scanners that permit the scanning of transparent media to create digital files. Or you could entrust the task to your photo lab. Then, as well as getting back your negatives, transparencies, or prints, you can have a digital copy on CD or DVD ready to slot into your computer. This comes at a modest cost—perhaps as little as $5 over the basic processing costs.

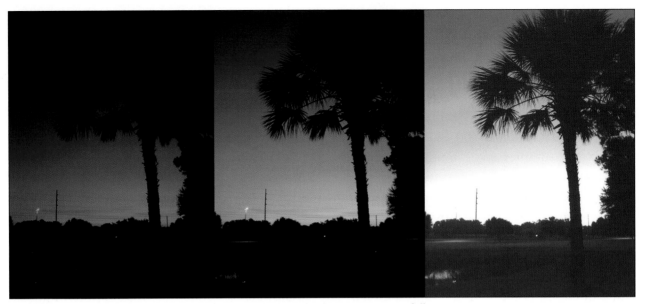

Autobracketing can be useful for low-light shots which tend, when cameras are fully automatic, to overexpose.

instinctively after a while, but it becomes more important in low-light work. Often, we will find light levels are so low that the camera struggles to focus; there is simply not enough light available for the focusing system to work. By focusing on a brighter component of the scene, even if it is not a principal subject, we can ensure that the camera has focused at the correct distance.

Exposure Lock. The Exposure Lock (sometimes called AE Lock) works much the same way. This time, we can point the camera at an object from which we want to take a light reading and lock this exposure setting into the camera. When we reposition ourselves for a shot, that exposure will be applied to the whole image. Again, this becomes a valuable tool for low-light work. Metering off the whole scene, as we discussed earlier, is prone to errors, yet by finding an element in the scene with the precise brightness or reflectivity makes it comparatively simple to expose the whole scene.

Histogram. A trend that is, fortunately, an increasing one is the option to display an Image Histogram on the camera's LCD. This has been a tremendous boon to the professional photographer and now an increasing number of other users are beginning to appreciate the power of this notionally innocuous graph.

For those familiar with Photoshop or some other image editing applications, the Histogram will need no introduction as it is no different than the same feature offered there. In fact, we've already discussed it here in its guise as part of the Levels dialog. It's a simple way to analyze the spread of tones in an image. The range of possible tones that can be recorded in an image ranging from the purest white (level 0) through the deepest black (level 255) are displayed along the horizontal axis and the amount of that tone in the image shown by the vertical axis.

To read the histogram, you need to look at the way the pixels are distributed through the graph. An image with a full tonal range (sometimes called dynamic range) will feature at least some pixels at every point along the graph. A lower contrast image (one with a more restricted dynamic range) will have the pixels gathered together more, with areas (to the extreme right or left) completely blank.

Night and low-light shots should also feature a full tonal range, but we'll have a distinct bias in the shape of the curve, with more pixels tending to occupy the darker (left-hand) end of the range.

The good news, if you find your shots don't have the right amount of dynamic range or if your camera doesn't have a histogram feature, is that you can (to a degree at least) correct for errors in the range later

with your image-editing application. See pages 30–31 for a practical example.

Autobracketing. Taking bracketed shots—one at the correct exposure, one under that exposure, and one over—is a good way of ensuring at least one perfect shot under problematic lighting conditions. An autobracketing control lets you take this sequence of bracketed shots automatically. You can preset the exposure difference (usually one stop, but anything from one-third to two stops) between shots, and the total number of bracketed images recorded.

◼ LENSES

Low-light photography makes particular demands upon lenses. They need to have wide apertures, be of good quality if we are to deal with high-contrast objects and prevent flare, and, collectively, accommodate a wide range of focal lengths.

Fixed Lenses. Of course, when it comes to discussions of interchangeable lens options, we're making the presumption that we're using a digital SLR. But where does this leave the users of other cameras? Not as disadvantaged as you might imagine. The fixed lenses that are provided with many digital cameras are capable of remarkable results across a wide range of conditions, including low-light work. Many cameras feature zoom ratios that sound mouth watering

to the users of SLRs. And, although it compromises the "all in one" philosophy that the manufacturers of compact and intermediate cameras are so keen to promulgate, it is possible to use subsidiary lenses to further extend the focal range both at the telephoto and wide-angle ends.

Changeable Lenses. But for ultimate flexibility, an SLR with changeable lenses has much to commend it. You can find lenses that offer extreme wide-angle coverage (essentially impossible with other camera types), extreme long focal-length lenses, and specialized lenses and zooms. Perhaps more significantly, you can get lenses with wider apertures that deliver exceptional low-light performance even if, as a rule, we tend to stop down our lenses to f/8 or less. Why? Because this gives us better depth of field (more of the image will be in sharp focus) and the optical performance of a lens is usually at its peak in the mid-range of the aperture.

There is a price premium with fast (wide-aperture) lenses. To own one, you can expect to pay two or three times the price of an equivalent lens that is a single stop slower. But for candid photography in particular, this stop could be crucial.

Many lens manufactures offer stabilized lenses. These have been designed to compensate for the minor vibrations and tremors in the photographer's

System lenses are ideally matched to an individual camera or series of cameras and allow the greatest degree of communication between lens and body for spot-on focusing and exposure

Wide-aperture lenses are more expensive than those just one stop slower but invaluable when the light fades.

A small nameplate is all that, on the outside, distinguishes an image-stabilization lens from a conventional one—but hidden from view are the complex electronics and mechanical assemblies that can give your shots that critical sharpness.

ance across an extended range of focal lengths is much harder than doing so for a single one. However, advances in computer design and the availability of specialized glass types have meant that, over the last few years, the gap between zoom and prime lenses has become very narrow. The differences are now so slight that, in practice, you would have to examine a large print very closely to discover any differences. As a result, for most purposes, the practicality of carrying a single zoom lens rather than two or three prime lenses makes an unequivocal case for the former.

More recently still, the lens makers have acknowledged the needs of the digital photographer and have produced lenses optimized for use with digital SLR cameras. They differ from ordinary SLR lenses (that have nominally been designed for 35mm-format film) in that they have been perfected optically to produce as fine an image as possible over the area of a digital sensor. This is typically two-thirds the size of a 35mm frame, so correcting distortions and aberrations over this area is less problematic in the context of a zoom lens.

So, when you are setting about adding to your collection of lenses think about use and think about the practicalities. Here are my suggestions, born from checking the well-used contents of my Nikon-based kit. The numbers in brackets refer to the equivalent 35mm focal lengths.

24mm f/2.8 (35mm): Great for wide-angle shots and interiors, pretty wide, and a good aperture.

50mm f/1.8 (75mm): This standard lens becomes a wide-aperture portrait lens in digital SLRs. The wide aperture gives the shallow depth of focus ideal for portraits and low-light work.

28–300mm f/4 (42–450mm): An ideal general-purpose lens to have on the camera at all times. Amazing focal range, even though there is mild image distortion at the extreme ends. F/4 isn't that fast, but is quite sufficient for most activities

hand when he or she is holding the camera. They work by a crafty system of gyros that detect and compensate for any movement. These command an even greater price. Worth it? Probably not. Unless you intend to do a lot of impromptu candid work, you'll be using a tripod most of the time, so your lens and camera should usually be pretty solidly mounted. I'd save the money and spend it on an additional lens or a wider zoom ratio.

That brings us to another contentious question. Do we equip ourselves with fixed focal-length lenses (usually referred to as "prime" lenses) or go for zoom lenses? The answer used to be pretty clear: prime lenses all the way. Prime lenses did, and still do, offer wider apertures and are better optically. Creating a lens that delivers perfect optical perform-

400mm f/5.6 (600mm): Good for closing in on detail, even if a little slow.

17–35mm f/3.5 (28–50mm): Good wide-angle zoom for framing interiors or street scenes.

◼ ELECTRONIC FLASH

In a book about low-light photography it might seem a little incongruous to discuss the use of electronic flash. Well, as we've seen, it's very useful to be able to augment ambient light with an artificial source. And the most versatile artificial source (and generally the most convenient) is the electronic flash. Let's take a look at some of the mechanics of flash units and study how we can get the best from them.

It's dangerous to make sweeping generalizations in the world of technology, but it's safe to say that virtually all digital cameras, save a few of the top professional models, boast an built-in flash unit. These vary in power and performance, from simple units with modest power outputs through to complex multimode units that have—for their size—quite prodigious outputs.

Built-In Flash. The benefit of these units is that they are always there—you don't need to remember to pack a separate unit. The downside is that the direct illumination they provide delivers harsh shadows and rather flat images. Also, where there are subjects at different distances from the camera, the illumination levels can fall off quite dramatically with distance. Red-eye, too, becomes an issue. Because the lens and flash are almost coaxial, light from the retinas of subjects reflects directly back giving them a demonic look. Some cameras offer red-eye reducing flash modes, but these rarely do more than slightly reduce the extent of the red-eye and total removal remains an exercise for the darkroom. Some cameras offer a Night Scene flash mode. This triggers the flash but keeps the shutter open to record more of the background. It can work well, but is rather limited in control.

External Flash. So what's the bottom line? For the night and low-light photographer, built-in flash units are too brash and uncontrolled to be useful.

It's always better to use an external flash system—and the best kind of external flash to use is a dedicated flash system. These units link with the camera's control system and work with the exposure system to ensure that the precise amount and type of light is delivered. The more sophisticated of these units can even alter the cone of light emitted to best suit wide-angle and telephoto lenses, giving a broad beam to ensure a wide angle of view is evenly illuminated, or a more concentrated beam to better illuminate more distant subjects with a telephoto lens.

The key benefit of using an external flash is that you can tilt, rotate, and swivel the flash head independently of the camera body. For our low-light work, this means that we can be more discrete with our lighting—perhaps illuminating a scene by reflecting the light off a wall, ceiling, or even, with sufficient power, a nearby building. This also leads to more even lighting. We just don't get the same tail-off in lighting that we did with direct flash. We can also balance the flash with ambient lighting by setting an underexposure amount to the flash.

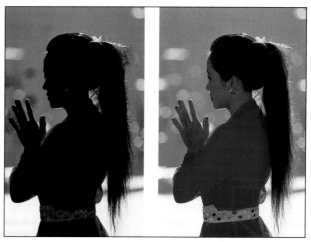

Fill in flash is an important feature of a flash unit, especially at low light levels. The effect is more dramatically illustrated in this daylight shot.

Connections. Back when all cameras used film of some type, most cameras featured either a hot shoe or PC sync socket, or both. The hot shoe allowed direct connection of the flash to the camera and the PC sync socket (the name has nothing to do with personal computers, by the way) enabled connection

Simple flash brackets let you mount a camera and flash together even when the former is not fitted with a hot shoe. A PC connector on this Casio camera makes it possible to exploit much of the functionality of the Metz flash unit.

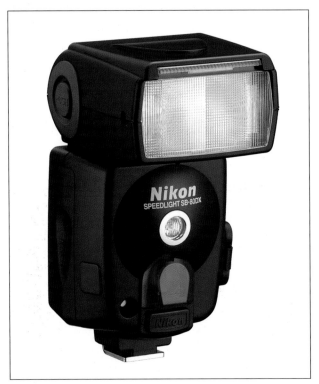

Some flash units, such as this Nikon model, are optimized for digital SLR cameras but offer additional modes that allow them to be used as slave flashes. You can configure the flash to operate as a slave in most of the modes that it can offer when attached to a camera directly.

of a separate flash (or flashes). Neither connection is so prolific on digital camera models and it's not until you arrive at the enthusiast or semi-pro models that these features debut.

Hot shoes not only feature a mounting point for the flash unit but also provide the essential electrical connections. In the case of a dedicated flash unit, these provide the flash with the information on the camera settings and feed back its settings to the camera. Where there is only a single contact, this will ensure that the flash unit fires at the same time as the shutter but no information is exchanged. In this non-dedicated flash configuration, you will need to set the aperture of the camera manually on the flash unit, making any adjustments for ambience that you consider appropriate. This simple connection is similar to that provided by the PC cord.

Some enthusiast and most professional cameras will feature a cord equivalent of the dedicated hot-shoe, featuring anything up to a ten-way connector. This will provide the highest level of dedication in all respects, whether you choose to use a single flash or a multi-head, studio-type configuration.

Slave Flash. I've noted that having a flash unit too close to the axis of the lens can cause problems (particularly with red-eye) and that directing the light to bounce from an adjacent surface can be much more effective.

We can extend that principal further, whether for creative or practical effect, by removing the flash from the camera entirely. We may, for example, want to place the unit deep inside our scene for selective illumination. A practical instance of this might be placing a flash to uplight a building or foliage. It is relatively simple to achieve this by attaching a suitably long cord (whether PC or dedicated), but for longer distances, or where a direct connection could be problematic, we have an alternative: slave flash. A slave flash fires on command, and that command is usually the burst of light emanating from an on-camera flash.

Slave flash units are available in many power outputs, and some dedicated units also feature a slave mode. Alternately, you can purchase slave triggers that will turn any flash into a slave. With these, a built-in sensor fires the flash via a hotshoe contact.

The more sophisticated slave units will offer more control, which is pretty much essential if you are

aiming to balance the output of several flashes in the same exposure. This will make it possible to get a great balance between, say, direct, accent, and ambient lighting. This is another area where digital scores over conventional photographic kit. Subtle balancing of light sources is difficult to master, but the option of previewing results immediately makes gaining a grasp of the concept much simpler. And the results will speak for themselves!

Preflash: A Cautionary Tale. I need to sound a note of caution at this point. Some digital cameras can fool slave flashes. These models, which are normally those we regard as the intermediate compact models, feature a cunning process for getting exposures right. They will emit a short preflash that (invisibly to us) illuminates the scene and records the reflectivity of the subjects. The camera can then evaluate the correct flash amount required for the exposure. Unfortunately for our slave system, this invisible pre-flash is all too visible to slave sensors and can trigger the flash. The result is a burst of precisely controlled light from all the flashes—marginally *ahead* of the camera's exposure!

To counter this, some flash units feature a built-in delay that accounts for the pre-flash delay. If you have a camera with this bonus feature (or think yours might), it's a good idea to check the manual before investing in a flash system.

◼ MORE POWER TO YOUR FLASH

Type "flash photography" as a search criterion in Amazon.com or your favorite on-line bookstore and you'll see that there are many worthy volumes devoted specifically to the subject. We don't have the space to go into every nuance here, but here are a few more issues to consider on the path to becoming flash savvy.

Batteries. You don't need me to say that, except for those of us fortunate to work in temperate or tropical climes, evening and night photography is synonymous with working in the cold! And in cold weather, the battery power we rely on to power our kit tends to diminish almost in parallel with the encroaching cold. Additionally, lighting the darkness

itself puts on onerous load on those batteries. It makes sense, then, to extend your power supply by using external, rechargeable battery packs. There are models to power most flash units and the batteries themselves are small enough to strap onto a belt. Better still, you can stick them in a pocket and keep them warm—extending their life considerably.

External battery packs also have the advantage that their inherently high power shortens recycle times and allows extended use—even with high-speed digital cameras. With conventional in-board power, you always run the risk of a dark shot in a sequence, visible proof that the flash is struggling to keep up with the camera.

Reflectors and Diffusers. We've talked about alternate positions for mounting our flashes, but there's yet another way we can bring about better light quality: using reflectors and diffusers. Reflectors modify light by interceding between the flash unit and the subject. It's rather like using bounce lighting techniques, but we ultimately have more control, because we can choose the type and even the color of our reflector and we can use reflectors in open country where there may not be a suitable surface to use bounce lighting.

Reflectors come in all shapes and sizes. Some are small enough to be strapped to the flash itself. Larger ones can be hand-held or tripod-mounted. For con-

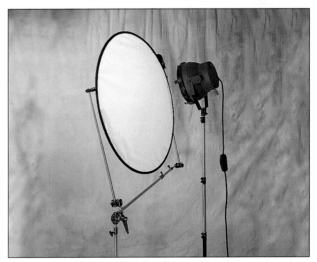

Reflectors are often thought of as studio devices but their compact nature makes them ideal for providing some serious assistance outdoors.

venience, these often fold away to a fraction of their deployed size. Umbrella reflectors featured a metallic interior to spread and diffuse the incident flashlight.

Diffusers, too, can be either small flash-mounted units or larger panels. Sometimes called softboxes, diffusers spread and soften the light further.

Extenders. SLR camera users will be familiar with teleconverters or extenders that convert a standard lens into a telephoto or a telephoto into a longer tele. You probably won't be surprised to learn, then, that some wise guys have applied the same philosophy to flashes. If you really need to illuminate distant objects (whether or not you are actually using a telephoto lens) this could be just the answer. Kirk's Flash X-tender can be used with most midrange telephotos (though 300mm or longer are advised) and increases the light output over the field of the lens by a factor of four.

■ SUPPORTING YOUR CAMERA

Virtually every textbook on photographic technique stresses the importance of avoiding camera shake. Subtle vibrations in both the camera and the photographer can conspire to take the edge off sharpness in an image and turn a remarkable shot into a good-but-ordinary one. You'll often be told that some form of solid support is essential for every type of photograph and every camera (something many reportage and candid photographers will take issue with), but there is no disputing the need for such a support in the case of night and low-light photography where, necessarily, exposures tend to be long.

A solid support is usually synonymous, in photographic circles, with a tripod—and we'll take a look at the practicalities and benefits of these later. But a tripod need not be the only option. If we don't have (or perhaps can't use) a tripod, there are plenty more resources we can press into use. The cut-off point where it becomes essential to use some sort of support is where exposures in excess of around $\frac{1}{60}$ second are called for. This is a rather arbitrary timing. With telephoto lenses, or when using the telephoto end of a zoom lens, camera shake is more obvious

and $\frac{1}{125}$ or $\frac{1}{250}$ second may be the slowest that can be used unaided. Similarly, at wider angles of view, we may be successful at $\frac{1}{30}$ second.

There's something of a rule (to which we should always default in favor of more caution that states that if an exposure time is longer than the reciprocal of the focal length of the lens being used, you need to use some support. So, if we're using a 300mm lens (and here we're taking 35mm camera equivalent) we need to use a tripod for any exposure of $\frac{1}{300}$ second or longer. If we ignore those who (sometimes with amazing success) claim to be able to hand hold to half a second, it always makes sense to provide some sort of firm support.

Non-Tripod Supports. Solid ground can often be the most convenient, and even softer ground will suffice for many applications. If the angle of view is appropriate, place your camera on the ground and click away. LCD panels, especially those of the tilt-and-swivel type, are ideal for viewing and framing in this situation.

More practically walls, automobiles, and even news stands can be pressed into service. Trees, light poles, and even telegraph poles can also provide good bracing.

The problem with most impromptu stands is that they rarely allow you to position your shots as you need. Tripods are blessed with heads, that part to which the camera is attached, that can be adjusted to almost any position with great accuracy. A simple

It's a pro-grade bean bag. This Kinesis offering takes up little space and provides valuable padding for your kit when packed away, yet provides a very versatile support.

bean bag slipped in your camera gadget bag can provide similar versatility with almost no weight—and at a nominal cost.

Tripods. For absolute versatility, you can't beat tripods. Adaptable for height, angle, and just about every terrain, they are the essential accessory for the low-light photographer. Finding the *right* tripod, however, is slightly more problematic.

Conventional tripods are made out of aluminum that has the benefit of being strong and light. There are countless models to choose from, ranging from simple consumer models through to large and (despite the aluminum construction) heavy professional ones.

If you plan to travel widely with your tripod, investing in a carbon-fiber model could be a great advantage. Such models are around a third lighter than their aluminum equivalents and have the advantage of being warmer to the touch—ideal for frosty nighttime location shots! Remember, too, that it's a case of the bigger the better—but that the biggest tripods are designed for studio use and are never meant to be thrown over the shoulder and taken on location!

The key criteria when selecting a tripod are the dimensions. That is, the size when fully extended, when at its lowest, and when fully collapsed. The last is an important factor, as it's the size the tripod will be when you carry it around. Tripod legs tend to consist of tubes or channels that can be locked in any intermediate positions using twist or flip locks. Doing so with some models can be fiddly; in these cases, you need to extend sections in systematic order—not something you necessarily want to be burdened with on a cold winter's night. It's a good idea to test a tripod not only for its stability and size but also for ease of use.

When it comes to size, most users want a tripod that, when extended, brings the camera conveniently to eye level. By "extended," we generally don't include the center extending column. Think of this as extra height for fine tuning the overall extension. Tripod manufacturers generally quote the height of their tripods excluding the central column for the

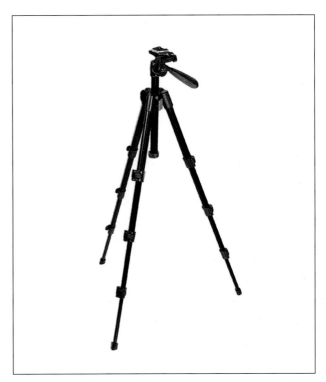

With four section legs and a center column, this tripod packs away to a very compact size. Check, before purchasing, that the tripod remains rigid when extended to its full extent.

good reason that when this is fully extended the overall stability can be compromised. Also, some professional models are completely modular—you can choose from a range of center columns.

Many tripods improve their stability by cross bracing. When the legs are splayed out, bracing bars link the legs to the center column assembly. This generally improves the rigidity but can compromise the flexibility of use. If your circumstances dictate that one leg needs to be splayed further than the other, you could find yourself restricted.

At the other end of the scale, in flexibility terms, comes the bent-bolt tripods. Popularized by brands like Benbo, the technology actually derives from military gun mounts. Field guns needed to be placed on rough terrain fast and securely. The answer was a mount featuring a bent bolt that, when tightened, locked together all the attached legs. Those legs could be freely positioned even at the most absurd of angles. The camera tripod shares the same design but adds a center column (also infinitely adjustable) and camera bracket.

Tripod Heads. Many tripods (and just about all consumer models) come complete with a head, that bit to which the camera is fixed. Professional models often give the buyer a choice. You'll find two key types: ball and socket, and pan and tilt. Ball-and-socket types are characterized by a metal ball to which a camera bracket is fixed. This sits in a socket, rather like a mechanical hip joint, in which is embedded a screw-threaded bolt. Release the bolt and the camera can be positioned at almost any angle and then secured by tightening the bolt. Simple and fast.

Pan-and-tilt heads tend to be slightly slower to use. These heads rotate around a vertical axis and carry a bracket that can be turned around a horizontal axis. They are great for precision positioning but come into their own with video and movie cameras where the range of motions ensure that (assuming the tripod has been accurately positioned) the camera remains precisely aligned with the horizon when moved. To this end you'll often find an on-board spirit level to ensure that you get the level spot on.

Still photographers tend to favor the ball-and-socket type, but it's all a matter of taste—try both and see which you feel more comfortable with.

Monopods. When a job calls for an adjustable support and a tripod is unfeasible (often the case in many interiors, where tripods may be banned) why not try a monopod? With just one leg, there are obvious instability issues, but braced correctly, with the photographer's legs completing a stable tripod formation, it's a great alternative for exposures of up to one second.

Tabletop Tripods. Sometimes called minipods, these tiny tripods fold away to almost nothing and can slip in your gadget bag. The benefit they have over a bean bag is that you can fit a small tripod head and position the camera to even more extreme angles. Lightweight construction means that they can be prone to flexure, but they're a great standby. Sometime you'll find minipods in a kit that includes a mounting spike (to stick in the ground or soft wood), a clamp, and even a suction cup for smooth surfaces.

Minipods like this pack away into a space not much larger than that taken by a pen yet provides rigid support for compact and even some intermediate-sized cameras.

■ SOFTWARE

The past decade has seen a period of contention in the photographic world. When is image manipulation going a step too far? For many photographers, any digital image manipulation is something of an anathema. Good photography should begin and end in the camera, they will argue. Probe a little deeper, and these same photographers will think nothing of allowing their photo printer to manipulate their work, nor would they express concern at the need to dodge or burn parts of the image to improve the end result. Image manipulation has existed since the earliest days of photography—indeed, back in those early days, intensive manipulation was often *essential* to reveal a contrasty image.

Today, even some of the more reticent of photographers will concede that image manipulation software can empower their photography. It can overcome the shortcomings of their equipment, or their subjects, to help (emphasis on *help*) create some great images.

Photographers who have embraced digital technology will be the first to tell you that the tools now available will never make it possible to produce a

truly great image from a so-so one. The phrase "garbage-in, garbage-out" is as pertinent here as anywhere.

Choice. If you are new to digital photography you may be surprised by the amount of choice available when it comes to image-enhancement software. There are applications that cost virtually nothing (existing in the freeware domain) through to the mega-apps that cost hundreds of dollars.

In this book, we have used Adobe Photoshop in our examples and demonstrations. This is the most comprehensive of applications and also that in widest use by both enthusiast and professional photographers. Yes, it is in the highest price band, but for day-to-day use, it certainly cannot be bettered. Yet it's not the only product worthy of consideration. When choosing what is best for a person's needs, I tend to discuss the options on the basis of four criteria: specification, ease of use, results, and price. Let's take a closer look at each of these.

Specification. There's a lot that can be done to an image. We may need to perform a physical edit, changing the size or cropping away unwanted detail. Tonal or color changes may need to be applied. After making changes or applying enhancements, we may also need to prepare the image for printing or publication. Each of these—and there are many more besides—requires specialized tools. Any application we shortlist must be able to offer a specification that will accommodate any tasks we may need. This is the most obvious way to segment the marketplace. It also makes for a convenient split.

At the top of the tree come the feature-laden applications of which Photoshop will be the best known. These offer all the specifications and features that you might reasonably expect, and quite a few more besides. With any one of these you can be confident that there is not a single image-editing task that is beyond your reach.

At the next tier are those applications that appear to have much the same in terms of features and functionality but will be short some of the upper-end tools. Typically, we would find the key editing tools are present, but some of the pre-press features (essential if you need to prepare images for publication in books and magazines, but irrelevant to those who output images to an inkjet printer or the web) will be missing.

At the bottom—in terms of our analogy, not in quality—are the more basic packages. These are ideal for fixing holiday shots that might be off color, have minor blemishes, or need pepping up. They are good at what they do but, overall, the range of features is limited. For our work with low-light and night images we need some of the tools that we won't find in this category.

Ease of Use. There's an implied caveat with a highly specified program: it will be, necessarily, complex to use. As a result, we need to be confident that if a program offers all the technical scope that we need now and in the foreseeable future that it will also wrap this in an environment, an interface, that is easy to use. This is an area where Photoshop really scores. It boasts the slickest of interfaces. In fact, many users don't recognize quite how slick it is until they try to use an equivalent feature on another product. I'm a strong believer (as all who use computers every day should be) that the user interface should help you achieve an end result rather than hinder you. It's something that Adobe (and some others) have taken on board and, when you work

Photoshop's interface can appear daunting, but fusers soon come to appreciate the slickness of the design.

with Photoshop day in and day out, it's something to appreciate.

Results. Results is a criterion that is sometimes neglected or given low precedence, but the reason we employ any image editor is to produce a quality result—an image that we can treasure ourselves, display on a wall, or otherwise share.

Price. A common saying states, "You can't put a value on quality." But of course you can—and it's usually pretty high! For those of us who live in the real world, price is a very important issue. It's no good auditioning the best-specified, best-performing software if its price precludes its ultimate consideration. We've already established that Photoshop is a very expensive package, as are the equivalent products, including Corel's CorelDRAW! If you can afford it, though, those are the ones to go for.

The good news is that there are plenty of alternatives in the category we described as "intermediate" that do just as good a job in 99 percent of the cases you are likely to encounter in your low-light manipulations. Most of these retail for $100 or less. Take a look at Corel Draw Essentials or Jasc's highly regarded Paint Shop Pro. Even Adobe recognize that Photoshop is overkill for most enthusiast photographers and offer a cut-down version of their flagship: Adobe Photoshop Elements.

Ostensibly similar to Photoshop, Photoshop Elements trims more from its sibling's price than it does the functionality.

■ EXTENDING YOUR REPERTOIRE

If you've been a photographer for some time you've no doubt accumulated some eclectic equipment. As well as one or more cameras you'll have, perhaps, a collection of lenses, some filters, flash units, and maybe even some more esoteric accessories. Some of these you'll use virtually every time you pick up your camera, others you'll use regularly, and some will rarely—if ever—see the light of day.

So it can be with software. Your key image-editing application will see frequent use, perhaps every time you unload your camera's memory cards. Then there are other pieces of software that are more specialized. Like your key accessory lenses, you'll use these regularly but not as a matter of course. And then there are those software products that you could so easily buy, because they seem so attractive at the time, but will probably never get the chance to hog some CPU time and RAM space on your computer. The sad thing is, many of these can be expensive. So what *does* comprise a good arsenal of supporting software. Here's a rundown of the top applications that earn their place on many enthusiasts'—and quite a few professionals'—hard disks.

Panoramic Software. Digital cameras, by virtue of their small sensors, don't give the same field of view as their conventional counterparts; to get the same angle of view with a digital SLR, for example, you need a lens with a focal length 30- to 40-percent shorter than that used to produce an equivalent image with a 35mm SLR. So for sweeping views you'll either have to invest in some pretty exotic lenses or take a more economic and, dare I say it, effective solution: panoramic software. Take a series of shots around the horizon, overlapping slightly, and this software will seamlessly join them into a single view. You can also produce spectacular vertical shots in the same way.

There are panoramic modules in many image editors (such as Photomerge in Photoshop Elements) but stand-alone products often offer more comprehensive features. Check out products such as Stitcher and Stitcher EZ from Realviz and Photovista from Roxio.

Realviz's Stitcher is an impressive application for producing panoramic views from individual shots.

Melancholytron, from Flaming Pear software, is a great way to add atmosphere to landscapes; even shots in bright daylight can take on a gloomy twilight look.

Andromeda's Scatterlight applies a star effect to every highlight in the image. The net result is often a subtle softening of the image akin to soft focus.

Plug-Ins. Plug-in effects filters extend the range offered by the host application and integrate with that host so as to appear in the same Filter menu. There really are tens of thousands of filters available, some as freeware (downloadable from the web), shareware (expect to pay $10 to $20), through to commercial sets. Because there are so many on offer, it pays to check out the usefulness before purchasing. Don't make the mistake that many did in the days of the traditional filter in buying wild and wacky filters in the expectation that the results would astound everyone with their spectacle. The results were always clichéd and never original nor pictorial. Some of the wild digital filters do much the same.

The filters that will prove the most long lasting are those that offer more subtle effects, including those that emulate some of the key set of photographic filters. For example, I've looked at some filters—such as Alien Skin's lightning effects—that are very versatile and have a high degree of realism.

Movie and DVD Production Software. We saw earlier how it is possible to extract still images from video footage. But that same software also has another use: you can make slide shows from your still images and, via the same or an associated product, burn that production onto a CD or DVD for sharing with friends and family.

The term "slideshow" can strike terror into the hearts of many; they remember those evenings spent as carousel after carousel of indifferent vacation photos were presented to an unsuspecting audience. Banish all such thoughts—today's movie applications help us make impressive shows that feature movement, transitions, and music unlike anything you've seen before. Applications such as iMovie let you zoom and scan across your images, blend them together, and add multiple audio tracks just like you see on the finest of television documentaries.

Burning the production to DVD helps not only archive your image collection (the original images can be stored along with the edited versions for the presentation) but also makes it much easier to view them. DVDs are burned in a format that can be replayed by all DVD-equipped computers and most domestic DVD players. You can even burn in the VideoCD format for even wider compatibility.

Ten Tips for Night and Low-Light Photography

For getting the best results when the sun goes down there's no substitute for experience. But on the path to image nirvana, take heed of these ten tips

1. USE A SUPPORT

Yes, every book on photography technique emphasizes the importance of using a tripod or other support and I'll be the first to reiterate that sentiment.

When the light levels are higher you can get away with hand holding your camera, but at night don't chance it. It *just won't work*. And there is nothing more disappointing than getting some ostensibly great shots on your camera's LCD display only to find when you look at them close up that they are ruined by a lack of critical sharpness—or worse. A compact minipod takes up very little space so there's no excuse, even if you can't carry a tripod.

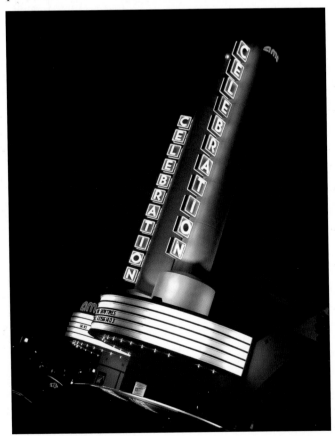

Don't forget the tripod: at ¹/₁₅ second, this shot is pin sharp with a tripod but ruined without.

Not only does a tripod (using that term as a generic one for any form of camera support) enable pin-sharp shots, it also helps with composition. With a fixed camera, you can spend more time concentrating on getting the best position of screen elements.

2. GO FOR THE FASTEST LENS

The faster your lens (the bigger the maximum aperture), the more light that can be collected during an exposure. An increase of one stop, say from f/5.6 to f/4, means twice as much light can enter during a given exposure. The downside is that lenses with wide apertures are more expensive, as we've already noted. Gaining twice as much in terms of light gathering power will often dent your bank balance by more than twice as much cash.

Interestingly, a wide lens is not always a panacea to your shooting woes. Such lenses might be well nigh essential for the sports photographer who has to combat low light levels and fast action, but for artistic photography, these lenses are not always ideal. Wide apertures often compromise image quality, particularly at the edge of the image where distortions and aberrations can be introduced.

3. TRY A STABILIZED LENS

If your low-light photography precludes the use of a tripod (for example, you want to take photos in interiors where tripods are banned and other supports problematic) then stabilized lenses are one solution. With a stabilized lens, you can extend the exposure range where you can successfully expose using hand holding and can further extend the range where you can use makeshift (but not rigid) impromptu supports, such as fence posts or walls.

Okay, so for most of us the price premium of a stabilized lens might rule them out, but if you're going to make low-light photography your number-one activity, that investment can very quickly be repaid.

4. BRACKET YOUR EXPOSURES

Early proponents of digital photography consigned techniques such as bracketing to history. Sadly this act was a little premature. Despite the capabilities of

the digital darkroom, bracketed exposures are still essential for getting the best results. This is especially true when recording images at low light levels where noise and high contrast effects can compromise images.

In fact, it's possible to use the best parts of several bracketed shots to create one perfect one. Cloning or copying parts of one digital bracketed image to another can overcome problems such as prominent digital noise.

Bracketing your exposures ensures that you get a result that is spot on, even if your camera judges exposure otherwise.

5. EXPLORE THE POSSIBILITIES OF HIGH ISO SENSITIVITIES

If a stabilized lens is out of your budget, then racking up the equivalent ISO sensitivity of your camera is an option. As we've discussed, digital cameras nominally operate at an ISO equivalent of 100, but most cameras can also work at 200, 400, or even 800. A few choice models can even achieve 1600. Like film counterparts, this enhanced sensitivity is not without its drawbacks (otherwise wouldn't we all set our cameras to the highest setting and forget about it?). Higher speeds generally compromise image quality. Noise levels will increase and the image will become more coarse. But if the choice is between a blurred image (or no image at all) and a little coarseness, you have to take it. And we can make amends later when we get our images on the computer.

Go on, be honest. Do you really know what every button does?

6. EMPHASIZE MOVEMENT

Okay, so I've made a particular point about removing all chance of unintentional movement in the camera through using a suitable support. But working at low light levels, and consequently, using long shutter speeds, means we can transform mundane subjects into surreal fantasies. Think about those trails from car headlights, firework tracery, and fairground illumination. The images we produce would be quite different if we were able to use very brief exposures. Even daylit scenes can become more dramatic if we limit the amount of light entering the lens.

7. BE ONE WITH YOUR CAMERA

Okay, so that statement may sound a little messianic, but it promotes an important truth. If you know all about your camera's performance and what it is capable of, you'll also know what it's *not* capable of, so you won't waste time and effort trying to achieve effects that your camera won't be able to deliver on.

Many of us only use part of our camera's capabilities—something we are often happy to accept. This is often out of fear; we don't know what some controls, particularly on digital SLRs, actually do, so we shy away from them. Come to terms with these features and your photography will instantly benefit. And with digital cameras, there's no collateral damage in the form of wasted film.

8. USE DIGITAL TECHNOLOGY TO YOUR ADVANTAGE

Digital cameras—and, in due course, digital-imaging software—are powerful tools that can only help boost your photographic prowess. You can see the results of your labors almost instantly; in a single evening you can achieve more in terms of developing your skills than you might in a season with a conventional camera. The ability to view your efforts imme-

diately means you can see how your technique translates into an image. And it means you can, before the memory of your efforts fades, take remedial action to improve results further.

9. CARRY SPARE BATTERIES AND MEMORY CARDS

Whether you use a conventional camera or digital, don't leave home without all the resources you need to keep the camera running. Digital cameras, more so than conventional ones, have a propensity to consume batteries at an alarming rate. More significantly, the loss of power can come quickly, particularly if you've been drawing power to operate an extensive zoom lens and flash. Make sure you carry at least two spares of the recommended battery type for your camera (no false economies with discount-store look-alikes!). Keep them in your pocket to keep them warm; when a battery gets cold it also compromises performance.

Memory cards? Digital photography lets us shoot away with a certain recklessness that would not afflict us if we were paying by the frame, as we do with film. So make sure you've plenty of memory-card space. And remember, sometimes memory cards do fail, so carry your storage as a set of medium-sized cards rather than one large capacity one.

10. PRACTICE, PRACTICE, PRACTICE

There really is no substitute for practice, but the great news is that digital techniques make it easy to reinforce your skills. Practice a few digital darkroom skills, too, and you'll be well set to deliver some stunning images! Revisit good or favorite locations to get alternate views.

Exposure Values

The table shown below describes a typical light level for a specific exposure value. The table shown on the facing page illustrates the various aperture–shutter speed combinations that produce the specific exposure value.

EXPOSURE VALUE	TYPICAL LIGHTING CONDITIONS
−6	Night, skyglow, and starlight only
−5	Night, no artificial lights, moonlight (moon up to four days old)
−4	Night, no artificial lights, moon up to half phase
−3	Night, no artificial lights, full moon
−2	Night, no artificial lights, full moon, reflective landscape (e.g., snow)
−1, 0	Dim ambient artificial light, dim street lighting in distance
1	Distant view of lighted skyline
2	Average value of lightning at five miles (time exposure)
3	Average value of skyburst fireworks (time exposure), candle-lit portraits
4	Floodlit buildings and cityscapes
5	Room interiors lit only with artificial light; subjects illuminated by bonfires
6	Brightly lit interiors; funfairs at night
7	Stage shows, concerts, sporting stadia at night, well-lit highways
8	Department stores' window displays, Las Vegas at night, incandescent light sources
9	Landscapes with sun 3 degrees (six diameters) below horizon, stage subjects illuminated by spotlights
10	Landscapes with sun up to 1 degree below horizon
11	Average sunsets, subjects in morning/evening open shade
12	Subjects in open, under heavy overcast skies
13	Subjects in open, under light continuous cloud
14	Subjects in open, under moderate haze
15	Subjects in open, under bright or hazy sun
16	Subjects under clear blue sky with sand or snow cover
17	Dazzling artificial lighting, spotlighting at close range (extremely bright)

SHUTTER SPEED	APERTURE												
	1.0	1.4	2.0	2.8	4.0	5.6	8.0	11	16	22	32	45	64
1 sec.	0 EV	1	2	3	4	5	6	7	8	9	10	11	12
½ sec.	1	2	3	4	5	6	7	8	9	10	11	12	13
¼ sec.	2	3	4	5	6	7	8	9	10	11	12	13	14
⅛ sec.	3	4	5	6	7	8	9	10	11	12	13	14	15
1/15 sec.	4	5	6	7	8	9	10	11	12	13	14	15	16
1/30 sec.	5	6	7	8	9	10	11	12	13	14	15	16	17
1/60 sec.	6	7	8	9	10	11	12	13	14	15	16	17	18
1/125 sec.	7	8	9	10	11	12	13	14	15	16	17	18	19
1/250 sec.	8	9	10	11	12	13	14	15	16	17	18	19	20
1/500 sec.	9	10	11	12	13	14	15	16	17	18	19	20	21
1/1000 sec.	10	11	12	13	14	15	16	17	18	19	20	21	22
1/2000 sec.	11	12	13	14	15	16	17	18	19	20	21	22	23
1/4000 sec.	12	13	14	15	16	17	18	19	20	21	22	23	24

Reciprocity Failure

*I*n books on conventional low-light and night photography there would be a big section, probably close up to the front of the book, that dealt in considerable detail with reciprocity failure. This worrisome bit of technospeak, which actually first appeared back in the early days of photography in the mid-nineteenth century, describes an unfortunate failing in the sensitivity and performance of film when long exposures are used.

Briefly, the correspondence between exposure time and aperture breaks down when using long exposure times. Under normal conditions, when you expose at f/8 for $\frac{1}{250}$ second you get the same exposure as if you shot at f/11 for $\frac{1}{125}$ or f/5.6 for $\frac{1}{500}$ second—there's a reciprocal relationship. However, this relationship

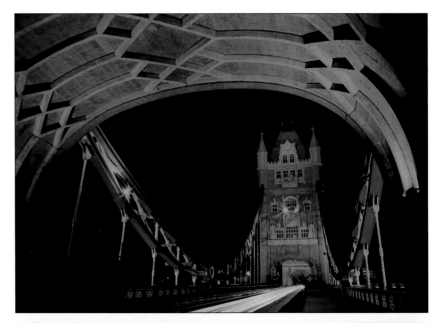

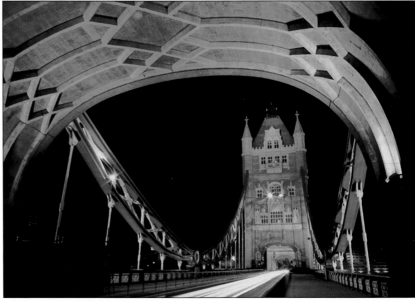

TOP—Metered exposure, Nikon F90 (N90), Fujichrome Provia 100, 180 seconds. BOTTOM—Corrected exposure, +2 stops, 5 red filtration.

FILM	EXPOSURE TIME AND FILTRATION		
	1 SECOND	10 SECONDS	100 SECONDS
Kodachrome 64	+1 (.5 orange)	Not recommended	Not recommended
Ektachrome 100	+½ (5 red)	Not recommended	Not recommended
Kodak Elite Chrome 400	None	None	+⅓ (70 yellow)
Fujichrome Velvia	None	+⅔ (10 magenta)	Not recommended
Fujichrome Provia 100	None	None	+1 (3 red)

only applies to exposure times nominally within the band of $\frac{1}{1000}$ second and 1 second. Outside this band, the reciprocal law breaks down. Particularly at slow shutter speeds, you'll need a longer exposure to get the results you'd expect. Not only do you need a longer exposure but the color balance will shift. The type and extent of shift (like the change in exposure needed) will vary with the film type, but it's often recommended that a color-correction filter is used on longer exposures for color fidelity.

Fortunately, digital sensors don't suffer from such failings. But, as if to show empathy with film, cameras that feature electronic imaging chips do suffer from noise problems when long exposures and low signal levels (that is, dark images) are prevalent. Minute random electrical discharges can be interpreted as brightness values, giving small hotspots in the image. In fact, this often manifests as something called a "fixed background pattern." You can reduce the dominance of this problem by ensuring that the CCD is kept cool. Sadly, this doesn't mean that allowing your camera to acclimatize to air temperature on a frosty evening—you need to make it much, much colder, using liquid nitrogen. Obviously, this is implausible for most users, but it's actually essential for astrophotography applications where the finest of details must be recorded accurately.

For those who still use film-based cameras for taking photographs, the charts above shows the reciprocity characteristics of some major films. The values given beneath each metered exposure value correspond to the increase in exposure required along with any necessary filtration that needs to be applied to correct the color balance.

Glossary

Airbrush Tool. Simulates the actions of the artist's airbrush. Sprays a soft-edge line using the selected foreground color. The size (shape) and opacity can be controlled using the brush and opacity settings.

Aliased, Anti-aliased. The inability of a pixel-based grid (as produced by a CCD or LCD display) to reproduce curved edges. Curved edges in images have a jagged appearance that can also affect diagonal lines (such as in type). This defect is known as aliasing. This can be concealed, to a degree, using anti-aliasing software routines that smooths jagged edges by adding intermediate pixels of intermediate color and tone.

Ambient. In photographic lighting, the light that exists in the environment. Usually comprises a mix of daylight (or sky light), artificial lighting, and direct and reflected light.

Analog. In digital photography terms, a recording system that represents the intensity of a signal as a value that can be constantly varying. Compare with digital, in which a discrete number represents all values composed of binary (0 and 1) code.

Aperture. The opening in a camera lens or lens assembly created by the iris diaphragm. Adjustable to allow more or less light to reach the CCD sensor or film plane. Can be controlled electronically or manually.

Artifact. Any image degradation brought about through the limitations of the digital processing or recording system. Low signal levels and image data compression can both produce unwanted artifacts.

Background Color. The color revealed when an element is removed from an image. It is also the end point of a color gradient. In Photoshop, background and foreground colors are displayed in small panels on the toolbar and can be changed by clicking on the respective color and choosing an alternative from the Color Picker.

Banding. A digital artifact that causes smooth gradients (such as the sky, or clouds) to be represented by stepped transitions. Often caused as a result of compression

Bit Depth. Also known as bits per pixel. A value that determines the color (or gray) value of an image. The greater the number, the more grays and colors that can define the colors in an image.

Bitmapped Image. An image stored as pixels as opposed to vectors. Conventional digital images can be described as bitmaps. Each pixel contains specific information relating to the color, hue saturation, and brightness of that point.

Blur Filters. Software filters designed to unfocus an image or an image selection. Often used to decrease depth of field or to soften the edges of a selection. Most image-editing applications feature a range of blurring filters of different strengths and types

Brush. A definition of the size and shape of the painting effect employed by a painting tool such as the Airbrush or Paintbrush.

CCD (Charge Coupled Device). The imaging chip at the core of a digital camera. The alternative CMOS chip is used in some cameras

Clipboard. Area of temporary storage in a computer's memory designed to hold image selections made using the cut or copy commands.

CMOS (Complementary Metal Oxide Semiconductor). Imaging chip used in some models of digital camera. Tend to consume less power than CCDs

Color Cast. A change in the color component of an image only; no change has occurred to the brightness or the saturation. Often due to tinted ambient lighting or incorrect film use. Image-editing software can be used to remove or enhance color casts.

Color Swatches. A set of colors that can be selected for painting. Can comprise preset colors or include colors used regularly by the user and sampled using the Eyedropper tool in Photoshop. Usually collected together in a palette.

Compression. A process in image-file handling that reduces the amount of data present in a data file. In digital photography, this means reducing the amount of data required to reproduce the image after saving. Lossless compression achieves the reduction in file size without compromising image quality. Lossy compression results in some of the original data being lost. When an image is repeatedly opened and editing of a file under this regime, losses tend to be cumulative and artifacts often become visible very quickly.

Crop Tool. Selection tool used to define the area of an image to be retained; the area outside is discarded.

DPI (Dots Per Inch). An expression of the resolution (as the number of discrete dots per inch that can be printed or displayed) in an output device. The similar term "Points Per Inch" (or "Pixels Per Inch") is used for input devices such as cameras and scanners.

Driver. Software application used to enable peripheral or installed devices (such as printers, sound cards, and digitizers) to work with the host computer

DV (Digital Video). Describes both the general format and, in capitalized form, the specific format used in consumer digital-video recording. Part of a family of similar formats that includes DVCam and DVCPro.

DVD (Digital Versatile Disc). A disc-based data-storage medium that features a family of discs including DVD Video (video and movie material), DVD Audio (high-quality audio), DVD-R (recordable DVD), DVD-ROM (data), and DVD-ROM (re-recordable). Note that not all DVD formats are equivalent or interchangeable.

Eyedropper Tool. Tool in Photoshop that can be used to sample a specific color from an image. Once sampled, that color becomes the current foreground color and could optionally be saved as a color swatch.

Feathering. The softening of the edges of a selection to make it appear to blend better with the background.

Fill Tool. Sometimes called the Paint Bucket, a Photoshop tool used to flood a selection with the current foreground color.

FireWire. Name given by Apple for the IEEE1394 interface and communications protocol. It is widely used to download video from a camcorder to a computer and, being bidirectional, uploading edited video to the camera (acting as a recorder) or separate video deck. It is increasingly used to download memory cards and images stored on cameras on account of its fast data transfer rate.

FireWire Card. Card mounted inside a computer (or an appropriate peripheral) to support the FireWire communication protocol. Many computers (and all

contemporary Macintosh machines) include FireWire as standard.

Foreground Color. In Photoshop, the color used to paint with when a painting tool is selected.

GIF Format. File format used to save (principally) graphic files used on the web

Gradient Tool. In Photoshop, a tool enabling a smooth transition between at least two colors or one color and transparency. Normally, a gradient is created between the foreground and background colors.

Grayscale. A color mode that displays an image in black, white, and 254 intermediate shades of gray.

Handles. Small boxes found at the corners and mid-points of the sides of selections. Depending on the feature, these can be used for resizing, distorting or rotating the selection.

Hue/Saturation. Command used to alter the hue (the color) of an image and the saturation (the intensity of the color).

Hybrid Camera. Term sometimes used to describe digital cameras that are notionally SLR in form but don't feature a direct-viewing system. They provide many of the features of a digital SLR but without the cost.

IEEE-1394. Generic name for FireWire connections and systems.

i.Link. Term used by Sony to describe its implementation of FireWire

JPEG Format (Joint Photographic Experts Group). File format used for saving image files, notable for its ability to compress images. Compressed images do, however, suffer from artifacts and degradation.

Layer. A virtual plane in an image that can be painted on or manipulated without affecting those above or below. Specialized layers (called Adjustment Layers in some applications) are transparent but modify the underlying layers in terms of color, contrast, or other variables. Called Objects in some applications

Lossless Compression. *See* Compression

Lossy Compression. *See* Compression

Marquee Tool. Selection tool that bases the selection on regular rectangular, elliptical, or (occasionally) other regular geometric forms.

Mask. Strictly, a term used to describe a coating applied to an area of an image to prevent manipulations and edits from affecting it; more generally an area of an image that is not actively selected is often regarded as masked.

MPEG (Motion Picture Experts Group). The compression standard MPEG-1 is used in VideoCD and offers quality similar to VHS on a standard CD.

MPEG-2 is used in the MicroMV format, DVB and DVD (although many variations exist). MPEG-4 is a multimedia format. Further standards, such as MPEG-7 and MPEG-21, exist for specialized applications.

Move Tool. Tool used to move a selection to a new position or move the contents of a layer relative to the contents of other layers.

Noise. Image-degrading signals that affect the original signal and result in poor image quality. Can be due to internal electronics or external interference.

Object. *See* Layers.

Opacity. Also known as transparency. A feature of layers and effects that enables them to be rendered opaque, transparent, or something in between (usually expressed as a percentage).

Paint Bucket Tool. *See* Fill Tool

Palette. An interface element that contains controls or settings for a particular tool or command. Unlike dialog boxes, that appear only when required, palettes are usually visible continuously (subject to context and whether a Show/Hide Palette command has been used). Palettes can often be moved freely around the screen or "docked" conveniently.

Pixel. Fundamental component of a digital image (the term is a contraction of "picture" and "element"), the smallest element of an imaging CCD and, by definition, the smallest element of the resulting image or video that can be recorded by the CCD

Plug-In. Small software application program that gives give added functionality to a host program. Extensively used for filters in Photoshop and other image-editing applications.

PPI. Pixels per inch, the standard unit for resolution description for input devices.

QuickTime. Apple's software application and system extensions for still and moving images and the automatic compression and decompression of the same. Included as part of the Macintosh operating system and available as a download for Windows.

Quick Mask. Mask applied using painting tools to aid in object selection. Masks and selections can be regarded as synonymous in many aspects of editing.

Resolution. The amount of detail in a digital image. The greater the resolution the greater the amount of detail that can be resolved. Images described as of low resolution are generally smaller (in file size terms) than that of higher resolution.

Saturation. The amount of a particular color in an image. The higher the saturation, the brighter the color; at zero saturation the image will be gray.

Selection. An area of an image (or sometimes the entire image) on which manipulations, edits, and transformations can take place. It is the active area. Areas outside the selection are described as unselected or masked.

Sharpening Filters. Filters designed to increase the perceived sharpness of an image. Usually work by increasing the definition of edges through increasing contrast. Photoshop includes filters that apply a constant amount of sharpening (Sharpen, Sharpen More) and the more controllable Unsharp Mask.

SLR (Single Lens Reflex). Type of camera in which the optical viewfinder shares the same optical path with the imaging sensor or film. The view through the viewfinder is generally very similar to that which will be recorded on film or digitally.

Stroke. When an object selection is stroked, a line is applied to the selection boundary (the color and thickness of the line can be user determined).

Transparency. *See* Opacity

White Balance. Camera setting that adjusts the color balance so that white and neutral objects are correctly rendered under different lighting sources. Most cameras now feature automatic white-balance controls that alter the balance according to the ambient conditions but these, and others, also have manual controls that can be preset for daylight, tungsten light, fluorescent light, overcast skies, and more.

Unsharp Mask. A sharpening filter that can be continuously varied by changing the amount of sharpening, the radius of sharpening (the number of pixels over which sharpening is applied), and a threshold. The threshold determines a minimum difference in pixel color and brightness values before sharpening is applied to prevent sharpening artifacts appearing on areas of constant color.

Vector Image. Images comprising vector elements (i.e., those determined by mathematical expressions rather than pixels). Vector images can be rescaled without affecting resolution (if pixel images are enlarged, the pixel nature becomes obvious).

Resources

■ BOOKS

Low Light and Night Photography: A Practical Handbook. Roger Hicks (David & Charles, 1991)

The Complete Guide to Night and Low Light Photography. Lee Frost (Amphoto, New York, 2000)

■ WEB SITES

This listing was correct at the time of compilation. Do bear in mind that web addresses can change, web sites can disappear or merge. Use Google or your favorite search engine to discover new or alternate sites.

Photoshop

Absolute Cross Tutorials (including plug-ins)—www.absolutecross.com/tutorials/photoshop.htm

Barry Beckham's Photoshop Tutorials—www.beckhamdigital.co.uk

Laurie McCanna's Photoshop Tips—www.mccannas.com/pshop/photosh0.htm

Planet Photoshop—www.planetphotoshop.com

Photoshop User—www.photoshopuser.com

Photoshop Today—www.photoshoptoday.com

The Photoshop Tutorials—www.the-photoshop-tutorials.com

Digital Photography

Creativepro.com (e-magazine)—www.creativepro.com

Digital Photography—www.digital-photography.org

Digital Photography Review (digital cameras)—www.dpreview.com

ShortCourses (digital photography theory and practice)—www.shortcourses.com

Steve's Digicams—www.stevesdigicams.com

Digital Camera Resource Pages—www.dcresource.com

Imaging Resource Pages—www.imaging-resource.com

The 123 of Digital Imaging—www.123di.com

Photo Dictionary/Encyclopedia—www.photonotes.org

Everything Photographic—www.ephotozine.com

Software

Photoshop, Photoshop Elements—www.adobe.com

Photosuite—www.roxio.com

Paintshop Pro—www.corel.com

Photo-Paint, CorelDRAW!—www.corel.com

PhotoImpact, PhotoExpress—www.ulead.com

Camera Manufacturers

Canon—www.canon.com, www.usa.canon.com

Fujifilm—www.fujifiilm.com

Minolta (and Konica)—www.konicaminolta.com

Nikon—www.nikon.com

Olympus—www.olympus.com

Pentax—www.pentax.com

Ricoh—www.ricoh.com

Sony—www.sony.com

Lighting

Mecablitz/Metz—www.metz.de

Sunpak—www.sunpak.com

Vivitar—www.vivitar.com

Tripods and Supports

Beanbags and flexible supports—www.kinesisgear.com

Gitzo—www.gitzo.com

Benbo—www.patersonphotographic.com

Manfrotto—www.manfrotto.com, www.bogenphoto.com

Uniloc—www.uniloc.co.uk

Velbon—www.velbon.com.au

Index